GAUGUIN

Nicholas Wadley

**GARLAND COUNTY
COMMUNITY COLLEGE
LIBRARY**
Hot Springs, Arkansas 71913

**TIGER BOOKS INTERNATIONAL
LONDON**

Original edition: Gauguin
© 1978 by Phaidon Press Limited, Oxford
Reprinted 1985
© 1988 by Phaidon Press Limited, Oxford
For this special edition
© 1988 by I.P. Verlagsgesellschaft
International Publishing GmbH., München
Published in 1988 for
Tiger Books International Limited., London
ISBN 1-870461-58-4
Printed and bound by Brepols N.V., Turnhout, Belgium

Acknowledgements

The author and publishers are grateful to those who have
lent photographic material and to the numerous institutions
and private collectors who allowed the reproduction of
works in their possession: Plate 34 Coll. Oskar Reinhart
'Am Römerholz', Winterthur; Plate 22 Museum of Modern
Art, New York, Mrs Simon Guggenheim Fund; Plate 59,
Colourphoto Hans Hinz; Plate 28, 29, Museum of Modern
Art, New York; Gift of Abby Aldrich Rockefeller; Plate 48
Museum of Fine Art, Boston, Arthur Tracy Cabot Fund;
Plate 60 Museum of Fine Art, Boston, Arthur Gordon
Trumpkins Residency Fund.

Gauguin

Art is a source of visual and spiritual energy. It stimulates and realizes our appetites for symbols, images and values. It gives form and direction to thoughts and moods of which we are sometimes only incoherently conscious, as well as creating new thoughts or new values, new dreams.

The art that lasts – most of what we call "great art" – is the art that can sustain that energy and intensity of experience in a way that is meaningful not only to different generations, but to different eras or centuries, sometimes even to different civilizations. We might be tempted to say that such art rises above taste to achieve a condition akin to "universal truth". But this is too simple and too exclusive. The vagaries of taste, its concern with ephemeral and anecdotal details, are all part of the meaning of art at any one time. The arbitrary fashion of any one epoch can tap new and very particular aspects or levels of great art's energy, just as the great art itself inevitably reflects the fashion and taste of its own time. A part of its quality as energy is that it can furnish universal and idiosyncratic truths equally well.

In Paul Gauguin's case, a large part of what has made his art so meaningful to so many lies in the image or presence of the man that is left behind (his actions, beliefs and lifestyle) as much as in the art objects he made. The objects stand as symbols of all that he stood for. In the modern world this is not altogether exceptional. Nor is the type of image he presents: hero *and* anti-hero, victim *and* tyrant simultaneously, as he confronted the modern dilemma of personal freedom. Gauguin resented the modern world and the reassuring force of his resentment still lives as a prop through his painting. He valued Man. He resented the debasing, debilitating, dehumanizing effects of an increasingly industrial society, of the bourgeois consciousness – things associated with "modernization" and "progress" – as well as what he saw as the "unnatural" influences of the Church and of sophisticated Western culture.

Picasso, his great successor as a legendary presence, was in no doubt of the significance in art of the artist himself. "It's not what the artist does that counts", he wrote, "but what he *is*. Cézanne would never have interested me a bit if he had lived and thought like Jacques-Emile Blanche, even if the apple he painted had been ten times as beautiful. What forces our interest is Cézanne's anxiety – that's Cézanne's lesson; the torments of Van Gogh – that is the actual drama of the man. The rest is sham."

What is exceptional in Gauguin's case is the degree to which this applies. He was seen as a symbol by progressive thinkers in his own time – "the supreme primitive man" Mallarmé called him, and Van Gogh wrote: "In my opinion, he is worth even more as a man than as an artist." His anxieties, dreams and hopes have remained a hypnotic focus of attention and identification for Western man ever since. His art stands as a set of symbolic images of these.

It is easy enough to belittle the popular image as drawn in *The Moon and Sixpence*, but "the actual drama of the man" has played a very real role in the minds of thousands. To read his art as something other than this *is* to deal in sham. The symbol of escape (from stockbroker's agent to painter; from Europe to an exotic paradise) was real to him and remains a real source of energy for others. Gauguin recognized the artist as a dreamer of his own and other people's dreams. His recognition of what art could do for the individual in the modern world sprang from his own needs and frustrations. The fact that he had the courage and stubborn determination to realize that possibility – even though it meant taking on

so much, and often in total isolation – has done much to keep the value of the dream alive. As well as giving marvellous copy to a popular romantic legend of escapism, this is essentially what his art means at any level. Whereas to get at the meaning of Van Gogh, most of us have to peel away several skins of popular legend equating madness with artistic genius and so on; with Gauguin this is not true. The biography doesn't shroud the paintings. Cézanne said that Gauguin wasn't a painter and, by French nineteenth-century standards, he was not essentially a painter. Painting as a medium was not a sacrament to him. Soon after his arrival in Tahiti he wrote to a friend: "You could say that I was born to make a trade from art and that I can't bring it off. Maybe glass, maybe furniture, earthenware or'that sort of thing – these lie at the heart of my natural abilities far more than what is properly called painting." (August 1892)

His attitude to the medium of painting was fundamentally different from that of Cézanne and most of his other great contemporaries. Gauguin made images – hard, clear, simple images that stay in the mind, reverberating through our consciousness. He shared little of the nineteenth century's concerns with a modern reassessment of a great European tradition of painting, nor was he much committed to the French involvement with the actual process of making the painting. The important thing for him was the fermenting of the *idea*: its translation into the painted image should be as rapid, uncomplicated and instinctive as possible. He was free of the French obsessions with technique, with *belle peinture*, with the actual stuff of the painting. "I detest this messing about with the pigment", he wrote, comparing himself to Vincent Van Gogh.

What is more, the images that he made in his mature paintings were to him essentially magical and symbolic, rather than in any sense records of what the eye saw. He condemned the Impressionists as "too lowbrow" because their paintings proceeded from the dictates of the eye and did not originate "at the mysterious centre of thought". His paintings came from the reality of the mind and the soul rather than from the external reality that the eye sees.

These differences isolate him from the mainstream of thinking among progressive nineteenth-century painters in France. The wilful, often apparently arbitrary violence of Gauguin's creative energy upset his senses of propriety in much the same way as Picasso's energy would do a few decades later. No wonder his mature paintings were anathema to Cézanne. Pissarro, too, came to view them with an incomprehension that stemmed from the very roots of these differences just discussed. After seeing an exhibition of Gauguin's Tahitian paintings, Pissarro wrote to his son: "I told him that his art did not belong to him. That he was a civilized man and hence it was his function to show us harmonious things. We parted both unconvinced. Gauguin is certainly not without talent, but how difficult it is for him to find his own way! He is always poaching on someone's ground: now he is pillaging the savages of Oceania."

Gauguin's antipathy to European senses of originality, of stylistic consistency or of harmony placed him outside Pissarro's terms of reference as a painter. And this, it seems, made it impossible for Pissarro to recognize that Gauguin's art was a conscious comment upon French or European concepts of "civilized man" and his "harmonious things". Gauguin resented for instance the overlaying of ancient myths by civilized man's rational and harmonious thought. He believed in the strength of myths. He wanted to make images that had the same

strength of value, a value that was both immediate and lasting. He gradually realized the confidence to make these images by whatever means were necessary to him, and not by the means laid down by convention or tradition.

What do we know of Gauguin the man? The Scots painter Hartrick, who knew Gauguin in Brittany, described him as "tall, dark-haired and swarthy of skin, heavy of eyelid and with handsome features, all combined with a powerful figure. Gauguin was indeed a fine figure of a man." Tall is one thing Gauguin was not: we are told elsewhere that he was only five feet four inches – one reason perhaps why he took so enthusiastically to wearing Breton clogs? Presumably the strength and stature of Gauguin's personality had coloured Hartrick's memory. Most of his contemporaries testify to a superior, aloof manner; to arrogance, ambition and a ruthless tenacity of purpose – a tenacity reminiscent of the little, yellow "old man of the sea" who sat like a human padlock on the shoulder of Sinbad the Sailor until he got what he wanted. Pissarro and Schuffenecker were among those who justly felt ill-used; Cézanne was outraged by what he saw as Gauguin's immoral and shallow plagiarising.

Obviously his wife Mette suffered most in personal terms. She writes of "the most monstrously brutal egoism, phenomenal and quite incomprehensible to me . . . he will never think of anything but himself and his well-being, he remains lost in the contemplative admiration of his own magnificence . . . His ferocious egoism revolts me every time I think of it." (Letters of 1893 to Schuffenecker). There is plenty of material from others around him to substantiate this side of Gauguin's image: a predator, wilful to the point of total immorality in art and life in the ruthless pursuit of his self-realization.

The pictures that are drawn by other contemporaries and those that emerge from his own letters are more erratic: they also show the vulnerable moments of self-doubt, anxiety and despair behind the facade. The poet Charles Morice records him breaking down in tears on returning from a farewell visit to his wife and children in Copenhagen, 1891, unsure about sacrificing his family for his art. A year later he wrote from Tahiti: "I am a great artist and I know it. It is because I am that I have endured such suffering."

An important part of the Gauguin legend's popular meaning is the mundane ordinariness of respectable bourgeois life from which he escaped. In fact, his family background and early childhood were anything but ordinary and they go a long way towards explaining the different pressures and impulses that formed his personality.

His grandmother was the famous Flora Tristan, writer and radical whose passionate, missionary-like campaign for social reform had been a feature of political life in provincial France of the 1840s, part of the pre-history of the 1848 revolution. Her husband, an engraver called André Chazal, was serving a twenty-year prison sentence for attempting to murder her. Flora was the illegitimate daughter of a Spanish nobleman called Tristan Morosco. It is some measure of the strength and extravagance of her personality that she persuaded her late father's brother (Don Pio, who lived in Peru) – on rather tenuous legal grounds – to grant her a small annual allowance. Not satisfied, she took a boat to Peru in a vain attempt to gain greater access to the substantial family wealth. She died in 1844.

Five years later, when Paul Gauguin was scarcely a year old, his father and mother took their two infant children on board a boat for Peru. The father, Clovis, was a

journalist on the liberal paper *Nationale*: the politically repressive aftermath of the 1848 revolution had persuaded him to seek a better start for the family than was likely in France. Tragically he died from a heart attack during the voyage. He was 35. On arrival in Lima, his young widow Aline and the two children were embraced into the heart of the aristocratic Morosco family, by now one of the most wealthy and politically influential in the country.

For the next six years Gauguin was surrounded by all the luxury and indulgence of a wealthy home and by all the exotic flavours of a South American environment. In 1855 this fairy-tale existence ended as abruptly as it had started. Civil war in Peru and the imminent death of Aline's father-in-law back in France conspired to induce Aline back to Europe. Within months the transformation was complete. Don Pio died in Lima and the substantial legacy he had left to Aline was successfully contested by his family and annulled. Aline set up as a dressmaker in Paris and sent Paul to boarding school. The account that survives of a solitary, withdrawn and problematic child is hardly a surprise.

An awareness of these early years can illuminate our reading of Gauguin's mature attitudes in two major respects, as well as in many minor ones. First of all, Flora Tristan came to stand as a symbol or yardstick of radical thinking, commitment and imagination. His instinctive assumptions of superiority and "the right to dare anything" came essentially from his awareness of her precedent. He treasured her memory, had her books with him till death and shared her beliefs in such things as the championship of the underpriveleged and a dismissive intolerance of mediocre conventions. Secondly, the experience – at an age when instincts and sensory values are shaped – of an exotic and non-European environment lodged very deep in his consciousness. His uprooting from an idyllic childhood in such surroundings and his subsequent planting in the educational context of middle-class Orléans would have sown potent seeds of resentment against Europe. Here perhaps was the real foundation of his longing for escape to a distant culture. In a sense it was not so much a dream as the longing to regain what had been taken from him. His decision to join the Merchant Navy was in keeping with an impulse to escape. As a seventeen-year-old apprentice he made two trips to Rio de Janiero and another around the world. After a year's military service in the French Navy, he returned to France. His mother had died while he was at sea and the family home had been taken over by his sister Marie. He lived with his guardian Gustave Arosa, a wealthy and cultured stockbroker, whose private art collection included a number of works by Delacroix (from the studio sale), Corot, Daumier, Courbet, Jongkind and Pissarro, as well as some oriental ceramics and metalwork.

The sympathy that Gauguin felt for Arosa and his way of life must account in part for the conformist pattern that his own life was to take for the next few years: his relative success as a broker's agent on the stock exchange, his behaviour as husband and father, his tasteful furnishing of the family house, the beginnings of his own picture-buying.

His image of himself cannot either for very long or very deeply have allowed that way of life to be entertained as a reality. The characteristics that were to colour his thoughts and behaviour as an artist emerge very rapidly after his marriage in 1873. His resignation from the bourse to devote himself to painting happened almost ten years later (January 1883), precipitated by the disastrous financial crash of the French stock market in 1882. But he had started painting by the mid-70s, spent a lot of his earnings buying paintings and, by 1880, the larger part of his energies were absorbed more by this pursuit than by his growing family or his job.

Whether one sees his life during the next five years –

1883–88 – as the product of obstinate self-indulgence or an enduring courage says more about the interpreter than about Gauguin. These years involved a transformation of his life-style from a bourgeois level of luxury to near-destitution; the gauntlet of humiliation at the hands of Mette's family in Copenhagen; continued and extreme frustrations of the illusions that he clung to of an early or easy living as a painter; the painful failure of his all-important first attempt to leave France for the tropics. The fact that he *did* survive and did then emerge in 1888 with those extraordinary and impressive paintings of his early maturity ensured that he would survive to the end. Until those paintings, he was living on faith: the biggest psychological hurdles – and it's these, after all, that the legend is about – were mounted in preserving faith against all outward signs of failure. With positive and very radical achievements as a painter under his belt, he could more readily preserve his self-belief and keep "outward signs" in perspective.

With the benefit of hindsight, we can see that his thoughts about painting in the mid-80s anticipate his maturity. In 1885 he writes to Schuffenecker (a fellow convert from finance to painting, Plate 38,) of the great artist as the senser of "the most invisible elements of the mind". He had in mind the sensation of phenomena that were "*surnaturel*" – beyond understood nature – and to which the artist was most finely attuned. He invokes Schuffenecker to consider the cause of our involuntary reactions to objects, reactions that lie outside our knowledge of those objects, and concludes that "there are noble lines and false lines, etc. The straight line gives infinity, the curve gives limits, that's without broaching the question of the "fatality" of numbers . . . Colours are even more expressive, though less various than lines, because of their power over the eye. There are noble tones, others are common; there are tranquil consoling harmonies, others excite you by their force . . . in our minds lines to the right advance, lines to the left withdraw . . . why are willows with hanging branches called "weeping"? Isn't it because drooping lines are sad? And the sycamore – is it sad because we plant it in cemetries? – No, it's the colour that is sad."

At the time Gauguin was living in Copenhagen, suffering Mette's family, failing to be a tarpaulin salesman during the day and painting in an attic in the evening. "At times I feel as if I'm mad", he writes, "but the more I lie in bed at night turning over these ideas, the more I believe I'm right . . . your friend Courtois is reasonable, but his painting is so stupid."

Such concepts of the reasonableness that one should or should not expect from great art are central to his mature art and its theory: the significance of a form in a painting lay in its expressive abstract properties, however obliquely, rather than its literal meaning. But at this point his ideas outstripped the sophistication of his abilities as a painter. His own paintings of Dieppe and Rouen (Plates 34, 35) have few of the "*surnaturel*" expressive properties, nor did they stretch very much the idiom of Impressionist painting with which he was working.

The ceramics on which he spent a lot of time working in the mid-1880s are rather different. In them we see a clearer expression of the force and originality of the man. Contact with this medium had come through the painter-etcher Félix Braquemond, whom he had met through Impressionist circles. Braquemond introduced him to Ernst Chaplet, the master ceramicist, who in turn showed enough interest to let Gauguin work in his workshop. With Chaplet's expertise and encouragement, Gauguin quickly mustered up enough visions of the financial success to follow to think that his chaotic circumstances would shortly be resolved. In 1885 he had left his wife in Copenhagen and returned to Paris with his son Clovis. Without any income, he took work as a bill-sticker to pay doctors' fees and sold paintings

from his dwindling collection to keep his son at school. His first stay in Brittany, a few months in 1886, was essentially an attempt to reduce the cost of living. Yet when he was offered a regular job with an advertising agency – a job he had worked hard to get – he turned it down for fear of distraction from his painting. Sales of his ceramics would, he thought, release him from this vicious circle of circumstances. It was not to be.

His work in ceramics was not predisposed to attract easy sales. By professional standards much of it was unsuccessful, incomplete and technically unorthodox. He wrote later that his intention had been "to inject a new spirit into the art of pottery by creating new forms made with the hand". Although in a very few cases he simply decorated an orthodox thrown pot (Pl. 14), almost all of the fifty-five or so pots he made at this time were modelled, away from the wheel, and their often highly unorthodox forms are as organically expressive in themselves as any decoration.

Whenever he talked or wrote about pottery, he stressed its coarseness and severity as a medium and the importance of preserving this character in anything you do with the medium. He talked romantically and with characteristically allusive self-allegory of "the figure burnt to death in the inferno" (of the furnace). The process of firing had a natural logic and harmony of its own that pleased him enormously. The material, he wrote, "becomes more grave, more serious according to the degree to which it passes through the inferno."

His disdain for "insipid coquetteries of lines which are not in harmony with a severe material" separate his ceramics from much of later nineteenth-century applied art in France. In Gauguin there is no hint of that exquisite sinuous elegance or perfumed delicacy of colour and pattern that gathered speed and intensity in *Art Nouveau*. Much of his work is heavy, asymmetrical and organically animated. Rather brutish peasant figures are trapped and dwarfed by a pot's swollen handles, and the level of invention often outstrips any consideration of the vessel's utility.

References to non-European ceramics – particularly to Oriental and to South American art – have been traced by historians of Gauguin's *œuvre*. We know that he shared with Chaplet and Arosa the current European taste for Japanese art and that both Arosa and Gauguin's mother possessed examples of Peruvian applied art in metal and ceramics. (His mother's small collection was lost when her house was burnt in the looting aftermath of the Paris siege, 1870–71.)

In general this burst of activity in ceramics seems important as the first real show of emancipation from conventional languages of art and design, of his ability to make new forms. What is more, Merete Bodelsen has shown what close anticipations of his mature painting style exist in the reduced linear language of his ceramic decoration. There is no doubt that this first significant experience outside the confines of "Fine Art" encouraged him to look at possible modifications of painting in a less inhibited way than had ever occurred to him before.

To date his painting had not shown daring so much as facility. It was a facility that encompassed conventions of academic sculpture (Pl. 12) and of naturalistic painting (Pl. 11) as well as those of the avant-garde idiom of Impressionism. His ceramics are recklessly inventive by comparison and it is quite on the cards that the missing pieces included ideas more extraordinary than those that have, often by chance, survived.

One that has since disappeared and that we know he valued very highly was included in a still-life group that he painted in 1886 (Pl. 37). It is an extraordinarily uninhibited formal invention, sheer fantasy as image and more ceramic sculpture than pottery in form. Artists of the avant-garde thirty years later have been credited –

for what such "firsts" are worth – with the invention of a sculpture concerned with internal and external spaces, broken and pierced surfaces and so on. Clearly Gauguin wasn't making that sort of conscious and polemical revision of sculptural values. He described his pots as "monstrosities", "made at the height of my madness". It was a flexing of his individuality. Several particular aspects survived from this flexing to play a part in his mature painting: the linear reduction of drawing, already mentioned, a new coarse ruggedness and inventiveness of form and contour, and a more personal attitude to colour that was to lead away from Impressionist concepts.

The 1886 *Still-life* is a living example. The use of the brilliant red hieroglyphs that jump out against the "head" of the ceramic figure is directly comparable to his free use of coloured elements in the glaze of ceramics. The 1889 *Self-portrait Cup* (Pl. 16 top) for instance has blood-like red streaks running accross the face. It was an expressive use of colour – only obliquely related to representation – that he discovered through his experience of ceramics. He often retouched pots after the glaze with lines of gold in the same way. It is a wilful and, by comparison with Impressionism, quite arbitrary use of intense colour localization, quite different from the Cézanne-based colour intensity in the 1886 *Still-life's* apples for instance. It was to become a hallmark of Gauguin's colour. He learnt what was almost a morality of good colour from pottery. He wrote in an article that "colours obtained from a single firing are always harmonious" and often, in describing the colour of a painting that he was particularly pleased with, referred to the colour qualities of his pottery pieces. Thus he wrote to Schuffenecker of his *Self-portrait (Les Misérables)* (Pl. 20): "The colour is a good distance from natural colour: conjure up for yourself a memory of my pottery, transformed by the inferno – all the reds and violets streaked by the bursts of heat, like a furnace glaring in your eyes, this battlefield of the painter's mind."

Two subsequent events encouraged the transition from exuberant potter to significant personal progress as a painter. First was the trip to Martinique in 1887 and then the second period in Brittany, 1888. The visit to Martinique, his first escape "to live like a savage", was in many ways total disaster. He went with the young painter Charles Laval. Disillusioned with the island of Taboga, they worked as labourers on the Panama Canal to earn the passage to Martinique, contracted dysentery and yellow fever and had to apply for repatriation. The paintings that Gauguin produced in Martinique while awaiting the return jouney (Pls. 18, 19, 39) have a quality of colour and pattern quite different from any earlier painting, induced by the tropical light, perhaps, as well as by the lush vegetation and by the excitement of his sympathetic response to an exotic, non-European environment. The compositions have a new characterful vitality: "far superior to my Pont-Aven period", he wrote. His new-found freedom in disposing the figures and trees of *Les Mangos* up and across the surface might be seen in relation to the decoration of his ceramics (cf. Pl. 14).

Back in Brittany, he formed a brief but important alliance with another young painter, Emile Bernard. This encounter acted as a catalyst. Inspired by Bernard's instinct to "fear nothing" and by the articulate intellectual authority with which he was arriving at very similar conclusions to his own, Gauguin launched himself into independence as a painter. He forced himself to change without knowing where it would lead him, but feeling a sense of certainty that "it is the road which truly corresponds to my nature."

Bernard, well-versed in Symbolist literary theory, was evolving a comparable theory for painting, in which the meaning of a painting would not be obscured by too many references to nature – the mind must not be too much distracted by the eye, he believed. During the previous year, he had been painting more from memory and imagination than from nature and had developed a simplified style of painting, influenced by Japanese prints, with austere colours and silhouettes and a reduced palette. It had been called "*Cloisonisme*" by virtue of its similarity to the *cloisonné* technique of medieval enamelwork.

The origins of the term Synthetism, by which this type of painting (including Gauguin's) became more widely known, are unclear. Gauguin would certainly have approved the term, if he did not invent it: reference to an ideal of "the synthesis of form and colour" held a primary place in his writing and thinking from 1887–88 onwards.

The 1888 *Vision after the Sermon* (Pl. 40) shows both Gauguin's response to Bernard and his response to Brittany. When he returned to Pont-Aven, after Martinique, he experienced a heightened identification with the simple rural environment. "I love Brittany," he wrote, "I find here the savage and the primitive. When my wooden shoes reverberate on this granite soil, I hear the muffled heavy and powerful note that I seek in my painting." The meaning of *Vision after the Sermon* is concerned with this sort of thinking: the unquestioning beliefs and superstitions of simple church-going peasant women are the real subject. The distinction between the reality of the figures and the unreality of their vision or dream is schematically rendered by a contrast between modelled form and flat colour. There are clear similarities to Bernard's style, especially among the figures of peasants. But the strength, originality and stark colour intensity with which the whole is brought together are quite distinct from Bernard's art. Bernard later became resentful of Gauguin's borrowing of formal ideas and of his accredited leadership of the "Synthetist" school. It is not a major issue and reflects, first, Gauguin's lack of conventional scruples about originality and, second, his greater stature as a creative artist. The ultimate character of his mature art owes little to Bernard.

Other 1888 paintings explore the same formal properties, like the strange *Still-life with Three Puppies* (Pl. 22) in which little pockets of Cézannesque painting are sealed off from any spatial relationship by the heavy contour and hang stranded against a vertical white ground. Shadows throughout the painting become extensions of the forms they echo. He wrote to Bernard on this subject: "I shall get away from anything that gives the illusion of an object, and shadows being the *trompe l'oeil* of the sun I am inclined to eliminate them. But if a shadow enters your composition as a necessary form, that is an altogether different thing . . ."

Some 1889 paintings include actual local examples of religious carving into reworkings of the theme of *Vision after the Sermon* (Pls. 42, 43). The paintings of 1888–89 include some of the finest of his career and certainly represent the high point of his pre-Tahitian œuvre. These two years were his most prolific as a painter. Nearly 150 canvases remain from this period, whereas subsequently he only twice painted more than thirty in one year (1891, 1892) and the more normal output was less than twenty.

He considered his greatest work of 1888 to be *Human Anguish (The Vintage at Arles)* (Pl. 41). Perhaps it was because it was the first painting that was completely his own: because he could now manipulate the techniques at his disposal and marry them to the oblique but profound sense of mood that he wanted his images to achieve. The image is suspended from the particular in any sense of time, place or narrative: the strange silent figures are isolated from each other. But at the same time the whole painting is redolent with a physical sensuality that is inescapable and immediate. It is a simple forceful image. Its particularities lie in the brilliant red nose of the otherwise sombre standing woman, or in the dramatic jumps of colour in the seated girl, from the Degas-like pink arms against blue and white, to the acid yellow-green of her face, to the livid orange hair and then back to the rich and mottled red surface behind – again so reminiscent of his glazed ceramics. The meaning is buried deep into this rich substance of colours and marks: it is both universal commentary on the human condition – "seeking a broad view of things", as he put it – and loaded with highly personal and autobiographical allusion. In this sense the brooding central figure is as much an image of himself as is the self-portrait in the 1889 *Christ in the Garden of Olives* (Pl. 46), a picture with very similar mood and meaning. That Gauguin wanted his painting to do all of these things is confirmed again and again by word and by image for the rest of his life.

Here for the first time he began to realize his earlier dreams of expressive colours and lines. The muffled, oblique meaning was also to remain central to his ideal of painted images. His unrelenting diatribe against naturalism in art pinned the blame on Classical antiquity. Compared to "the pure cerebral art" of the Egyptians, "all art from the Greeks onwards is an art of decadence – the more or less great artists are those who have reacted against this error." Just as he maintained faith in the simple beliefs of a primitive people by comparison with the oversophisticated – hence impoverished – condition of European culture, so in art he made a parallel comparison between the allusive painter symbolism that he sought and what he considered the over-literary symbolism of European painters like Puvis de Chavannes. "He is Grecian, I am a savage."

Time and again he repeats the maxim: "Painting should seek suggestion not description." "The essential part of a painting is that which is not explained."

This was one of the main points of contention between Gauguin and Van Gogh during their three months together in Arles at the end of 1888. While Vincent too was seeking a symbolic expression from painting that was lacking in Impressionism, he could not in the event come to terms with the oblique obscurity of Gauguin's symbolism, nor with Gauguin's insistence on imaginative abstraction as superior to the thing seen. The clash of temperaments sharpened Gauguin's confidence and his ambition. He conceded later that "I owe something to Vincent and that is the consolidation of my previous pictorial ideas" and, on the other hand, that he had transformed Vincent from "an uncertain searcher whose painting was nothing but the mildest of incomplete and monotonous harmonies" into one who "seemed to divine all that he had in him"!

He also called Vincent "a romantic, while I am rather inclined towards a primitive state". Increasingly he saw himself as the outsider. Earlier in 1888 he had written to Mette: "Since my departure, in order to conserve my moral strength, I have gradually suppressed feelings that come from the heart . . . You should remember that there are two sides to my nature, the Indian and the sensitive. The sensitive has disappeared so that the Indian can move forward with conviction." This had a particular context – he was watching himself steel his emotional instincts about the family he had left – but the self-image as one who is necessarily apart recurs.

Just before his departure for Arles he had described a self-portrait (Pl. 20) to Schuffenecker in these terms; ". . . one of the best things I've done; absolutely incomprehensible because it's so abstract. First of all the head of a bandit, a Jean Valjean of *Les Misèrables*, but also personifying the rejected Impressionist painter, forever bearing the bondage of the world. The drawing in it is very special, a complete abstraction. The eyes, mouth, nose are all like flowers on a Persian carpet, also representing the symbolic side. The colour is far from natural . . . This is all on a yellow ground, strewn with childish bouquets. It is the room of a pure young girl. The Impres-

sionist is just such an innocent, unsoiled as yet by the putrid kiss of the École des Beaux Arts." (By "Impressionist" here he simply means "modern painter": this was common usage).

As well as for its insistence on the abstract expressive properties of the image, the passage typifies Gauguin, in its vision of himself as the modern painter, as outlaw. Here he alludes to his lot being in common with all artists who choose to stand outside conventions, and his early ambitions for the escape to Tahiti resemble Van Gogh's dreams of an artists' colony or community. Gauguin entertained thoughts of a tropical colony including Bernard, Schuffenecker, Meyer de Haan, possibly Van Gogh, and others, but – with hindsight – it is difficult to imagine the venture any other way than it was: a solo mission. In the succession of melancholy, brooding and oppressively insistent self-documents that he produced from 1889 onwards, his art revolves exclusively around his own condition.

The most memorable of these self-images include the satirical haloed devil of the 1889 *Self-portrait* (Pl. 45); the withdrawn solitary Christ of the *Garden of Olives* (Pl 46) and two disturbing ceramic heads, the one streaked with red (Pl. 16 top), the other black with a nightmarish sense of isolation and withdrawal (Pl. 16 top), of which he wrote "the Gauguin of the pot, his hand being paralysed by the heat, as is the scream which tries to escape his lips." Lastly there are the two reliefs (Pls. 48/49). Of these the carved *Soyez Amoureuses et Vous Serez Heureuses* most fully demonstrates the character of Gauguin's art at this point. Dominated by a bleak self-portrait ("Gauguin as a monster", he explained), it incorporates decorative, symbolic and literary elements. It was a time of bitter recriminations between Mette and himself, in which he complains that his transgression of the conventions of marriage are being punished by the withholding from him of news of his children. His thinking was in terms of an immoral suspension of real human rights for relatively artificial, socially-prejudiced motives. In its time the relief was condemned as an erotic fantasy: in fact it was a very personal and coolly ironical allegory. A painting of two years later is in a similar vein. The "model" for *Loss of Virginity* (Pl. 51) was Juliette Huet, who had just borne Gauguin's child; a wedding party winds its way through the landscape and the image again includes the chorus-like presence of the fox, "Indian symbol of perversity".

These are further identifications of Gauguin as "monster" in the two works entitled *Oviri*. The name is inscribed in the 1893–94 self-portrait relief (Pl. 49) and is the title of his largest ceramic piece (Pl. 27). It makes the most obvious sense to see such references as Gauguin recording the European verdict on such outlaws as himself. But it becomes clear with time that he did not passively accept the role; he assumed it, lived it, fostered it. This was the Indian that replaced the sensitive; the primitive that replaced the European. The self-portrait relief was made on his return to Paris after the first Tahitian period, and was an assertion of precisely that; "the European Gauguin has ceased to exist", he declared. The tragic other side of this coin was, of course, that when he arrived finally in Tahiti in 1891, the indigenous Tahitian culture had also ceased to exist. Colonials and Christian missionaries had been there too long. "It was Europe," he wrote despairingly, "the Europe from which I had thought to free myself."

The eighteen months or so preceding his departure had formed another period of despondency, his life spent between the poverty and isolation of Le Pouldu in Brittany and his frustrated fund-raising campaigns in Paris. The letters of this period reveal the psychology behind the legend most poignantly. To colleagues like Bernard he writes of the rotten state of Western culture and predicts that beneath its battering, all artists, thinkers and seekers after enlightenment are bound to perish. Pos-

sible salvation lies in an escape to the tropics: "A man with the character of Hercules can gain new vigour like Antaeus out there – simply by touching the ground. After a year or two I could come back strong and revitalized." Possible locations for this restorative process were first Tonkin, then Madagascar and finally Tahiti. He painted little. His art he felt was clumsy and inept and could only reach fullness when it completely expressed his own personality: "I feel it but don't express it yet . . . What I am after is a corner of myself I don't yet know." Early in 1890 he wrote to Schuffenecker comparing his waiting condition to that of a rat clinging to a barrel adrift in the middle of the ocean.

Later in the same year the scene changed. His reputation among younger painters (notably Denis, Sérusier and the other Nabis), and among the writers and critics of Symbolist circles (Morice, Mallarmé, Aurier, etc.) was growing rapidly. Of the Post-Impressionist generation it was Gauguin at this point who held the stage; Seurat's following was waning, Cézanne's massive influence was still to come. Maurice Denis remembered him later as "the undisputed master . . . He furnished us with one or two simple and obvious true ideas at a moment when we were completely at a loss for guidance . . . He was ferociously individualistic and yet he clung to popular traditions, the most universal and anonymous ones. We derived a law, an instruction, a method from these contradictions." (1903). With the help of these admirers a large exhibition and sale of his work was organized in Paris, February 1893, which realized far more than enough for the trip to Tahiti. More than this, Morice also helped him to acquire a government mission as a painter; this meant a substantial reduction in the cost of his sea passage, outward and return, and the promise (in the event not honoured) of state purchases of some of his paintings when he came back. It also assured him of a respectful reception in Papeete, the Tahitian capital. Papeete was a miserable anti-climax for him, a piecemeal colonial harbour and shanty town. After three months he escaped the claustrophobic society of settlers, diplomats, civil servants and traders to move to Mataiea, a small settlement with a population of 500 or so on the south coast of the main island. He rented a simple bamboo hut.

The environment and the simple way of life, while they held obvious practical difficulties for him (he couldn't live like the natives because he couldn't hunt, fish and cultivate crops like them), gradually made him feel better in himself. "Little by little civilization is leaving me, I begin to think simply . . . I have all the pleasures of a free life both animal and human, I am escaping the artificial, I am penetrating nature. With the certainty of another day like today, just as free and as beautiful, I am developing normally and no longer have needless worries."

The paintings of the first Tahitian period are comparable in many ways to his Breton paintings: they depict the normal daily life of the local population, a few posed figure paintings and some landscapes. Nevertheless they are not simply objective paintings. In his own words, he painted "what my heart has permitted my eyes to see . . . what my eyes alone would not have seen". The light and colour dazzled him and while he felt inhibited from responding fully, conditioned as he was by "the timidity of expression of degenerate races", his art, too, slowly relaxed and expanded into a rich repertoire of image, pattern and colour. By the end of 1892 he had produced the greatest and most typical of his early Tahitian paintings (Pls. 52–55) as well as working intensively on notes for the first two manuscripts, *The Ancient Maori Cult* and *Noa Noa* (Pl. 30). Most of the ritual, custom and religious belief of Maori culture was dead and – although he did apparently see a few examples of carved wooden pots and dishes in Papeete – so too was the indigenous art and craft, all buried

beneath a century or more of Europeanization. The sources of his own researches into the subject were second-hand and themselves European – largely a two-volumed book, *Voyage to the Islands of the Great Ocean* (1837) by J.A. Moerenhout, a European diplomat. This disappointing fact meant little in face of Gauguin's enthusiastic appetite for information: he soaked up what was available, re-wrote it and assimilated it into his painting and carving as a vital living force. "What a religion this old Oceanic religion!" he wrote to Serusier. "What a marvel! My brain is bursting with it and all the things it suggests to me will frighten everybody." In the manuscripts he enriches the closely copied written material with succulent watercolour illustrations, rich and inventive in their imagery, his imagination fired. In paintings like *Moon and the Earth, Words of the Devil* or *Spirit of the Dead Watches* (Pl 55), the mythology is digested deep into the thinking that had formed his Breton paintings. Each painting unfolds an image of man submitting to unquestioning beliefs that offer the only available meanings or clues to daily existence. The screen of ambiguity thrown up by Polynesian mythology was just what he sought, what he had been feeling for in the way of life and religious beliefs of the Breton peasants, and was exactly in tune with his instincts about the use of painting's language ("the important part of a painting is that which is not understood"). The messages should be oblique, the questions should not have easy answers, the images should not be over-explicit. Characteristically he often draws from diverse sources simultaneously. *The Market* (Pl. 54) is a contemporary scene in the manner of an hieratic Egyptian relief. *We Greet Thee Mary* (Pl. 53) is basically a Christian image with haloed Virgin and Child and an angel, but the inscription is in Kanaka and the two Tahitian attendants are in poses borrowed from the photograph of a Javanese temple relief that he had obtained at the Paris World's Fair of 1889. All are blended in a rich tapestry of decorative, almost heraldic landscape devices and strata of exotic colour. *The Spirit of the Dead Watches* he has described in detail (Pl. 55): a drawing from life and his literary researches into Tahitian beliefs are brought together in a highly elaborate symbolic image. The evocative juxtaposition of images is paralleled by an extraordinary juxtaposition of different modes of painting within the one canvas, from the baldly aggressive fabric design in the foreground to the more open and elusive painting beyond the bed, where colour shifts and undulates across a ground that defies spatial definition. In essence it is the same concept of divided realities that he first attempted to convey with the *Vision after the Sermon* (Pl. 40). Here it is the physical reality of the naked girl and the coexistent reality of her fears and superstitions. His control of the means of painting (what he called the "musical part") to convey such concepts (the "literary part") has matured beyond recognition. His painting of bodies is physically highly sensual – see also the related painting of five years later *Nevermore* (Pl. 64); there are closely observed reflected lights, the subtle coloured sheen of a dark skin and so on, but seldom much trace of European eroticism. There is still a framework of stark simplicity of image, such as he had used in 1888, but it is now luminous, full of hidden lights, and of a subtle strength and vitality.

All of this repertoire is geared to the making of a potent symbolic visual image. Far from Paris he produced a body of work, some eighty or ninety paintings, that was in no sense "painting about painting", no *l'art pour l'art*. Yet when he writes to a painter in Europe, we can almost sense an involuntary switch in his mind, moving to a different wavelength of thought. "My canvases appal me", he says, "never will the public accept them. They are ugly from all points of view and I shall only know what they really are once I am in Paris and you have all seen them."

As early as June 1892, only a year after his arrival in Tahiti, he had put in a request for repatriation to France. The twelve months' delay until mid-June 1893 may have been due simply to the slowness of the bureaucratic machine, but more likely was aggravated by the hostility towards Gauguin of Governor Lacascade. The same man had rejected Gauguin's application for an official mission in the Marquesas Islands several months earlier. The paintings betray little of his fairly rapid sense of disillusionment with Tahiti, nor his extreme poverty, nor his illness: during the first three months in Papeete, he underwent hospital treatment for an advanced syphillitic condition and from that point until his death his health was in steady decline. The more we learn of the hard facts of his life in Tahiti and of the run-down French colony that he was living in, the more we recognize that he was projecting in his paintings not the reality, but the tropical paradise that he would have wished to find, building a legend of an ideal Tahiti.

The two years back in Paris, August 1893 to June 1895, were eventful, but contributed little to the development of his ideas or his art. Of an exhibition of his work at Durand-Ruel's Gallery, he wrote to Mette: "It was a great artistic success, even arousing furious jealousy. The press treated me as they have never yet treated anyone, that is to say with respectful praise. At present I am, in the eyes of many, the greatest modern painter. Thanks for your invitation to Denmark, but I shall be fully occupied here for the whole winter, with plenty to do: many receptions, visitors who want to see my paintings, buyers I hope . . ." By all other accounts the exhibition was by no means a success, nor was he subsequently besieged by the attention of admirers. He showed forty-four paintings and two carvings. Degas was one of the few admirers among his former friends. The exhibition sales did little more than cover expenses. This was to have been his triumphant return to Paris. The letter to Mette was an effort to save face, after his optimism that success here might finance a new start to their family life together. Subsequently their correspondence deteriorated into a volleying of accusation and counter-accusation. They never met again.

He did little painting in France; only the extraordinary image of *Anna the Javanese* (Pl. 57) and the melancholic *Breton Girl Praying* (Pl. 58) maintain the achievement of his best Tahitian works. The rest seem somewhat synthetic memories of Tahiti. In other media, he modelled the memorable self-portrait relief (Pl. 49), cut the inventive and influential woodcut illustrations for *Noa Noa* (Pl. 59) and made his largest and strangest ceramic work, *Oviri*.

The rest of this interval in France degenerated into a non-productive expenditure of time and energy. With the benefit of a legacy from a recently deceased uncle in Orléans, he lived reasonably well. Apart from Charles Morice and Daniel de Monfried, he seldom saw his old acquaintances, and made little effort to do so. His regular companions included William and Ida Molard (his neighbours), their twelve-year-old daughter Judith and their circle of friends, occasionally his old mistress Juliette Huet and constantly his new mistress, the thirteen-year-old Anna.

In May 1894 he returned to Brittany, first to Pont-Aven and then to Le Pouldu, where he befriended the painters O'Conor and Séguin. It was in their company that Gauguin was involved in a brawl with some drunken fishermen in a neighbouring village. Gauguin ended on the ground, his leg fractured by kicks from their wooden sabots. A painful three-month convalescence followed, during which he determined to leave France and the bestial stupidity of European life for good. "I shall be able to end my days a free man", he writes to de Monfried, and further to this, ". . . no more painting, apart from any I do to amuse myself. My house will be of carved wood."

Back in Paris he organized a sale of his paintings in February 1895. He asked Strindberg, whom he had met through the Molards, to write a catalogue introduction. When the reply was no, he used Strindberg's long letter of refusal instead. The sale was not successful, but made a modest profit. Degas bought two of his works at this time. After further extensive hospital treatment for syphillis, he left again for Tahiti late in June.

This time he rented a site on the West coast, a few miles south of Papeete, and had his own house built. The cost of this and of his reckless lifestyle consumed his considerable capital within a matter of months. Very soon he was back in debt and writing desperate letters back to friends in France. By 1897 his health, too, had declined dramatically: running sores on his body, an inflamed eye that prevented him from painting, severe pain from his fractured leg that confined him to bed and finally a series of minor heart attacks. In April of that year he learnt (almost casually) of the death of his daughter Aline, his favourite child, from pneumonia. In bitter grief, he finally broke all contact with his wife and family. In the same month his landlord died and he was turned out of his house. All of these factors combined to precipitate an unsuccessful suicide attempt, either at the very end of December or the beginning of January. In the event he swallowed too much of the arsenic and was violently sick.

His last testament, before his intended death, was the great painting *Where do we come from? What are we? Where are we going?* (Pl. 60). Apart from the pointedly pessimistic rhetoric, this is the effective subject of all of his mature paintings. Painted against time, in a violent bout of activity, it brings together all that his art and thinking and writing had tried to encompass, "induced by my feelings of vagueness and ignorance concerning the mystery of our origin and our future". The central axes are, to the right, the Garden of Eden figure plucking an apple and, to the left, an imaginary primitive idol. The juxtaposition of Christian and non-Christian religious images is one that by now we are used to in his painting. (His friend of the 1890s, Sérusier, had been involved in theosophical ideas and a matter of weeks before he embarked on this painting, Gauguin had written, in a long and involved essay on Catholicism, of the essential similarities between all world religions.) The message here is of universal philosophy, above any sectarian, racial or cultural differences. Read from right to left as Gauguin described it, the great decoration moves from birth and the innocence of ignorance and superstition, to the thirst after knowledge, and finally, in the shadow of the idol, to a doom-laden anxiety bred from reasoning. In this reading the hunched figure of the old woman to the left, a descendant of the 1899 painting *Human Anguish* (Pl. 41), is the climax. Read from left to right, we can recognize the shape of Gauguin's personal hopes of salvation in escaping the troubled world of the thinking European to the simple state of a carefree primitive paradise. This is at the heart of his identification with the "Indian", the "savage" and his despising of "the putrid kiss" of Western culture. The religious images offer little hope. The painting offers no answers to the questions of its title, any more than life itself in 1897 offered any rationale of past, present or future to Gauguin.

Over twelve feet in length, it was the largest and most ambitious painting of his career. Charged with the bitterness and desperation of his suicidal condition, it was painted very broadly and relatively quickly. The organization of all the elements of the frieze, disparate in scale and significance, is impressive. The large-scale "musical" tapestry of colours and undulating landscape elements beyond controls the surface and unites its symbolic characters. By European standards, this great painting is strangely artless nevertheless, distinct enough from Parisian painting ("this is no Puvis de Cha-

vannes, you understand") to make us realize that when he was involved in the work in no sense did he feel that he was painting for an audience among Parisian painters or that "I shall only know what they (my paintings) really are once I am in Paris and you have all seen them", as he had written in 1892. After his renewed contact with Paris he felt that no more; in fact he probably felt that in Paris he knew least of all "what they really are".

The paintings from 1898 onwards are richer again and more relaxed. The second, smaller frieze-like painting, *Pastorale (Faa Iheihe)*, in the Tate Gallery, London (Pl. 61), is a paradise-like answer to *Where are we Going?* It is a warm sensual carpet of golds and reds and the same mood pervades the other late Tahitian pictures.

Much of his creative energy in this second Tahitian period was devoted to carving. A large part of his œuvre as a sculptor is dateable to this period and it is reasonable to assume that a considerable number of other works have perished. We know that he made a number of pieces in perishable media (wax on earth for instance). We also know that when he moved to the Marquesas Islands in 1901, the new owner of his Tahitian house destroyed several pieces (as well as many of Gauguin's papers) by dumping them in the sea. Others were given away and left to rot. The renowned sculpture of a nude woman – in wax on earth – that stood outside his house and so outraged the local Catholic priest, or the animal pieces that excited the interest of the natives, we know only from photographs and written accounts. In the *Soyez Amoureuses* relief (Pl. 48), already discussed for its symbolism, Gauguin was improvising technically. The making of the piece is not explicitly informed by any traditions of carving. In general terms you might say that it is related more to the language of painting, but it is also true that in carving – as in his ceramics – he felt less inhibited by existing conventions and through spontaneous improvisation came upon ideas that could later be assimilated into his painting. The changes of texture, colour, scale; of the depth of carving and of the whole manner of carving (from decorative or formal to illusionistic) all reveal the same freedom and scale of invention that is visible in his ceramics. This applies to most of his carved works, and no less to his inspired use of the woodcut medium, where a savage artlessness of technique is employed for expressive purposes.

In Tahiti, of course, he was often forced to improvise with materials for economic reasons, but timber was more readily available than paint and canvas and the large part of his improvisation sprang more likely from his need to invent and to enlarge the language of art. The different materials used in the *Idol with a Shell* (Pl. 25 right) are an obvious example of this.

In his paintings there is no substantial use of Polynesian art forms, since no traditions existed from which he could borrow. In some of the carvings, however, there are decorative motifs and stylizations which are compatible with extant examples of Marquesan carving (Pl. 25 left and right).

Among his papers at his death were photographs of wood-carved Maori house decorations. This probably inspired the realization of his earlier dream to build a "house of carved wood". While not Maori in its decoration, the carved and painted wooden panels from the entrance of his Marquesan house, the "*Maison de Jouir*", were his assimilation of native practice. The other, and probably most famous of the carvings from these last years were the satirical, caricatural effigies of Monsignor Martin and his housekeeper-presumed-mistress. Gauguin entered the public political arena in Tahiti in 1899, at first on grounds of personal discontent and from a wish to avenge the disdainful bureaucratic treatment he had suffered intermittently from the authorities since his first arrival. He wrote a series of letters and articles for the political journal of the Catholic Party, *Les*

Guêpes, largely directed at the Protestant Governor. Soon afterwards he founded his own short-lived satirical journal *Le Sourire*. This activity seemed to satisfy him and to consume most of the energies he had previously given to painting. In his last years he painted relatively little and for long periods not at all. Earlier he had abandoned painting when forced for economic reasons to take a minor job as draughtsman with the Department of Public Works, but now he was getting more than enough to live on from sales of paintings in Paris, as well as his fees from *Les Guêpes*. He seemed for a while to have enjoyed the social status that his journalistic activities acquired for him among the Papeete population. What is more, Bengt Danielsson's detailed research has revealed that relatively little of Gauguin's writing in this context was on behalf of the repressed native population, as had been widely believed. His enemies' accusations that he was a hired political hack, slinging mud for the money, were not without a grain of truth. One extraordinary political speech of Gauguin's that Danielsson translates is in protest at the scale of Chinese immigration to Tahiti. "Does not the barbaric invasion of Atilla, described in the history books with such horror, pale in comparison?" he asks. "... This yellow blot on our country's flag makes me blush with shame." It is a speculative side of Gauguin, unseen since the Bourse, that casts new light on part of the legend at least.

In 1899 a contract from the Parisian dealer Vollard assured Gauguin of a regular income from his painting for life and of the supply of all the materials he might need. When a large back-payment arrived in 1901, Gauguin decided to sell up in Tahiti and to realize his long-standing idea of moving to the less civilized Marquesas. He settled in Atuona on the island of Hivaoa, built a two-storey wood and bamboo house of his own design and returned to painting with an energy dormant since the mid-1890s. The themes re-echo the Tahitian œuvre, but the paintings include some vital and original colour harmonies and, in paintings like *l'Appel* and *Contes Barbares* (Pls. 62/63), a poignantly disquieting mood.

For the first months his tranquil solitary life in Atuona seemed perfect, but in 1902 both his illness and his insatiable appetite for protest against the colonial authorities were revived. Disagreements with the island's gendarme and the resident Catholic bishop – again on grounds that were personal or on behalf of the French settlers as much as in the cause of the natives – came to a head with accusations against him of incitement, subversion and "libel of a gendarme in the course of his offi-

cial duties". On this last charge Gauguin was summarily sentenced to three months imprisonment and fined. A long and detailed letter of appeal was one of the last he wrote. He died in his house a week later, on 8 May 1903.

Gauguin's escape from Europe was a massively important symbolic act for the next generation. It was paralleled in importance by his escape from an art of appearances into an art of musical abstraction, of symbol, of allegory. "Colour, which like music is vibration, achieves what is vaguest and most universal in nature. We have just emerged from a period of confusion", he explained to Morice, "It was caused by physics, chemistry, mechanics and the study of nature. In it the artists lost all of their natural savagery, all their instincts, one might even say their imagination ..."

His painting realized the fruits of Baudelaire's dreams, dreams of fields dyed red, and of his regret that art was constantly demeaning itself before nature. Gauguin made a case for art never to demean itself; but to remain in a state of constant vitality, free from stagnation into stereotype or system, free from national or cultural boundaries, always able to re-energize and refresh itself. The definable debts to him of artists as different as Matisse, Munch, Picasso, Nolde, Chagall testify to the strength and viability of the case he made. "I have wished to establish the right to dare anything", he wrote in 1903, and when he claimed that "the public owes me nothing, since my achievement as a painter is only moderately good, but the painters – who today profit by this liberty – they owe something to me", he did so with justification. The subsequent history of art has borne him out.

When the comprehensive memorial exhibition was mounted in Paris in 1906, it might well have seemed like a visual language from another world. He was right, as Cézanne had been right: they were not great paintings in the French sense, but they were great and lasting images. It is diffcult for us, particularly with our different measure of the force of visual images bred from an age of film and television, to recreate in our minds the quite extraordinary experience that a huge exhibition of Gauguin's painting and sculpture would have imposed on Parisians at that time. It was not just that he used a graphically simple and reduced language of often startlingly flat strong colours, lines and silhouettes; not just that he disdained a coherent sense of technical style; not just that he turned his back so radically on nineteenth-century naturalism; not even only that his highly expressive art, sometimes lyrical sometimes hostile, was couched in the visual environment of a non-European

culture. It was the fact that his paintings, carvings, prints, drawings and ceramics combined all of these radical properties and more: that collectively they gave off such a raw and relatively barbaric sense of energy, such a powerful sense of an individual sensibility that was a law unto itself. We shouldn't look to measure his influence in stylistic derivations so much as in the heat of artistic radicalism and liberation that it generated.

Gauguin explained more than once in his letters and notes that an artist's painting is essentially the exposition of the man himself, implying that its value to other men lay precisely in this. "Those who reproach me do not know all there is in the nature of an artist", he complained to his wife in 1891 and most of his personal resentment against society revolved around this issue of misunderstanding. "I am a republican because I believe in social peace," he writes in the *Cahier Pour Aline*, 1893, and then enters an argument that still has currency today: "I believe every member of society has the right to live and enjoy a standard of living in accordance with his labour. An artist cannot live. Therefore society is badly and criminally organized. It may be argued that an artist does useless work ... whereas a man who makes something which has a value in terms of money enriches the nation. I would argue that *only* the artist enriches the nation. What is of value in his work remains even after his death. This is certainly not true of the money-broker."

What we can say about the content of Gauguin's art is that it was concerned with the quality of life. The dissatisfaction with the quality of European life that motivated each direction he took, he shared with many contemporaries. Like them he was a child of his time, affected by its political malaise, its social and moral change and its radical thought generally. But the intensity and the scale with which he expressed his dissatisfaction were extreme, as was the degree of duress that he inevitably brought upon himself. Not surprising that he writes at the end with exaggerated jealousy that no-one had influenced him in his art. He had spent the last few years in total isolation from the facts of European art other than his own selection: those in his mind, those already assimilated, those of which he had reproductions on the wall of each tropical studio. Just as in his memoirs he fantasized certain elements of his own biography, so in his art he reigned empirically supreme over all his resources, making different collages of all that was available. The 1906 exhibition was a major event in the history of modern painting. Gauguin himself was a major event in the history of our culture. The energy remains.

The Captions

11 **Study of a Nude** (Suzanne Sewing)
115 × 80 cm. 1880. Copenhagen, Ny Carlsberg Glyptotek. W39

12 **Bust Portrait of the Artist's Wife, Mette**
White marble, h. 34 cm. 1877. London, Courtauld Institute. G1

13 (top) **Breton Girl**
Charcoal and pastel, 33 × 48.2 cm. 1886. Chicago, Art Institute.

13 (bottom) **Seated Breton Girl**
Pastel and watercolour, 30 × 40 cm. 1886. Paris, Musée des Arts Africains et Océaniens.

14 **Vase Decorated with Breton Scenes** (two views)
Glazed and incised stoneware, h. 29–5 cm. About 1887. Brussels, Musées Royaux d'Art et d'Histoire. G45.

15 **Still-life with Japanese Print**
73 × 92 cm. 1889. New York, Private Collection. W375

16 (top, left) **Self-portrait, Tobacco Jar**
Glazed stoneware, h. 28 cm. 1889. Paris, Jeu de Paume. G66

16 (top, right) **Cup in the Form of a Self-portrait**
Glazed stoneware, h. 19.5 cm. About 1889. Copenhagen, Kunstindustrimuseet. G65

16 (bottom) **Portrait of Ingel Fallstedt**
Black chalk, 20 × 25 cm. 1877. Gothenburg Art Museum

17 **Self-portrait with the Yellow Christ**
38 × 46 cm. About 1889–90. Paris, Private Collection W324

18 **Aux Mangos** (Fruit Gathering)
89 × 116 cm. 1887. Laren, V.W. Van Gogh Collection. W224

19 **La Mare**
90 × 116 cm. 1887. Munich, Bayerische Staatsgemälde-sammlungen. W226

20 **Self-portrait** (Les Misérables)
72 × 90 cm. 1888. Laren, V.W. Van Gogh Collection. W239

21 **Van Gogh Painting Sunflowers**
75 × 92 cm. 1888. Laren, V.W. Van Gogh Collection. W296

22 **Still-life with Three Puppies**
Oil on wood, 82 × 63 cm. 1888. New York, Museum of Modern Art. W293

23 **Cows in a Landscape**
Watercolour, 26.4 × 31.9 cm. About 1889. New York, Collection S. Kramarsky. W343 bis

24 (top) **Women at the River** (Auti Te Pape)
Woodcut, 20 × 36 cm. 1891–93. New York, Museum of Modern Art.

24 (bottom) **The Gods** (Te Atua)
Woodcut, 20 × 35 cm. 1891–93. New York, Museum of Modern Art.

25 (left) **Hina**
Carved wooden cylinder, h. 36 cm. 1891–93. Collection Mme Huc de Monfried. G95

25 (right) **Idol with a Shell**
Carved ironwood and mother of pearl, h. 27 cm. 1893. Collection Mme Huc de Monfried. G99

26 **Père Paillard**
Carved wood, h. 69 cm. About 1902. New York, Collection Chester Dale. G136

27 **Oviri**
Glazed stoneware, h. 73 cm. About 1894–95. Paris, Collection J. Ulmann. G113

28 29 **Les Saintes Images and A Quoi Pense-Tu?**
Two pages from the manuscript *Avant et Après*. 1901–93.

30 **Two pages from Ancien Culte Mahorie**
Pen and watercolour. 1891–93. Paris, Louvre, Cabinet des Dessins.

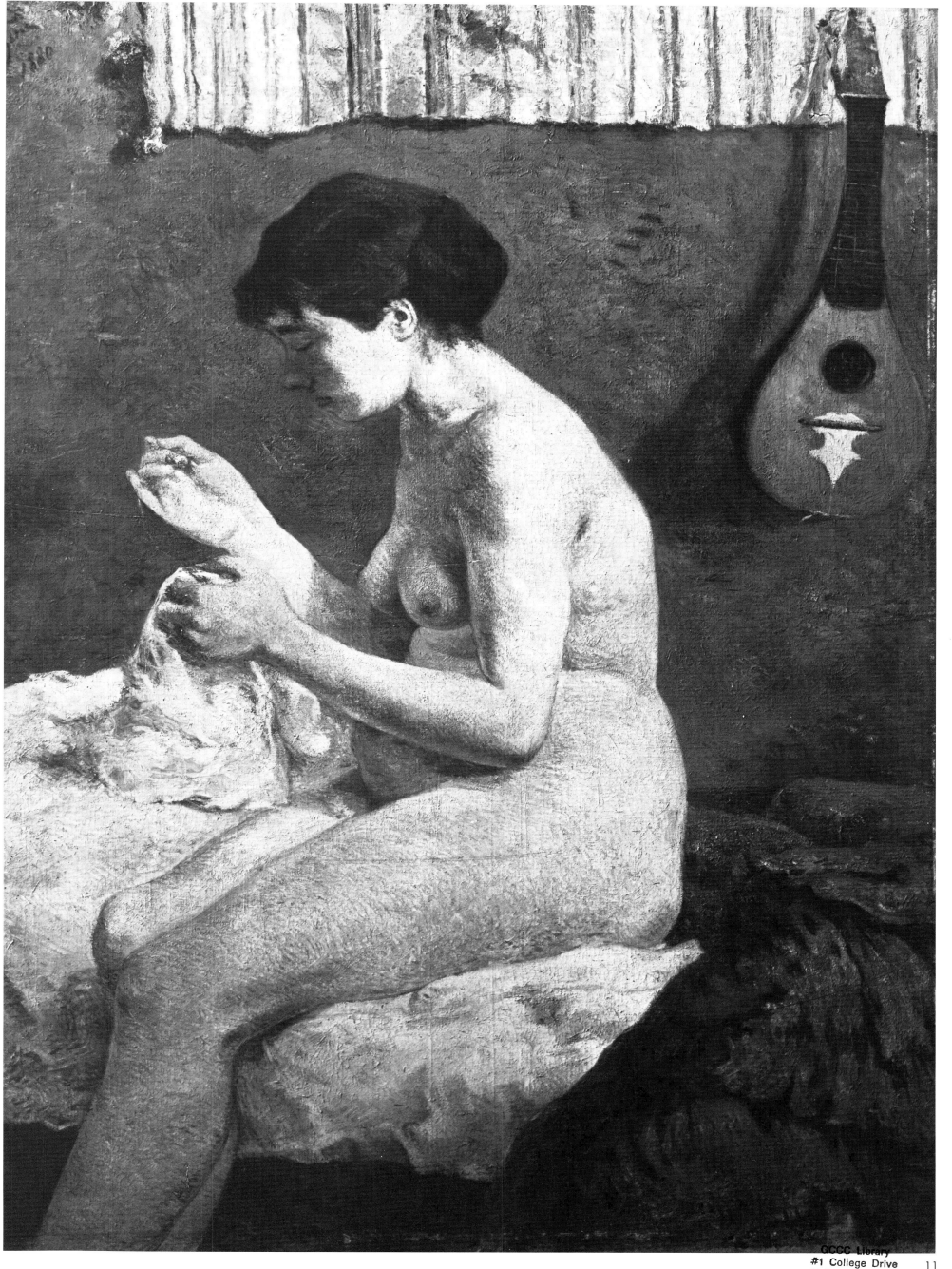

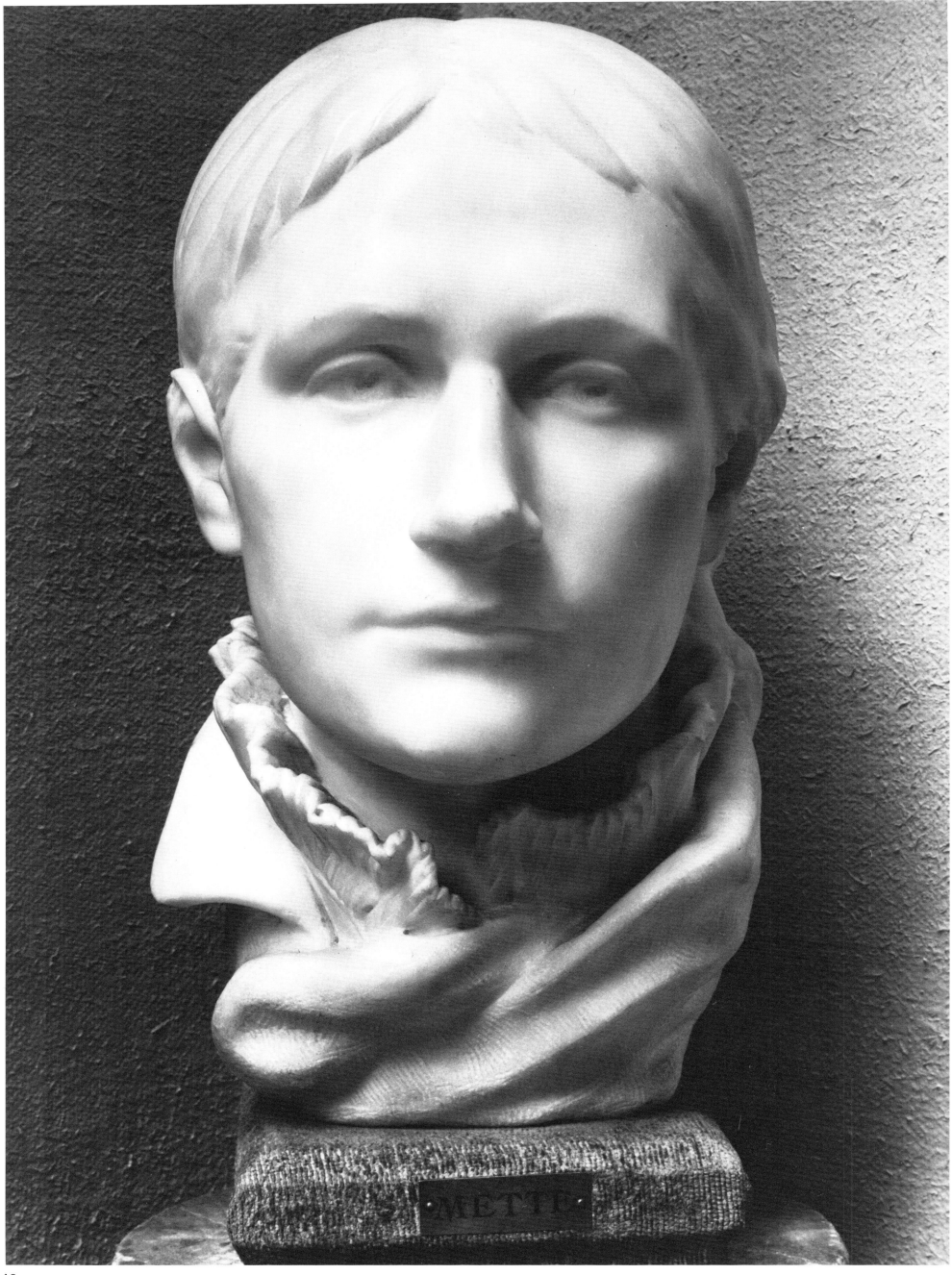

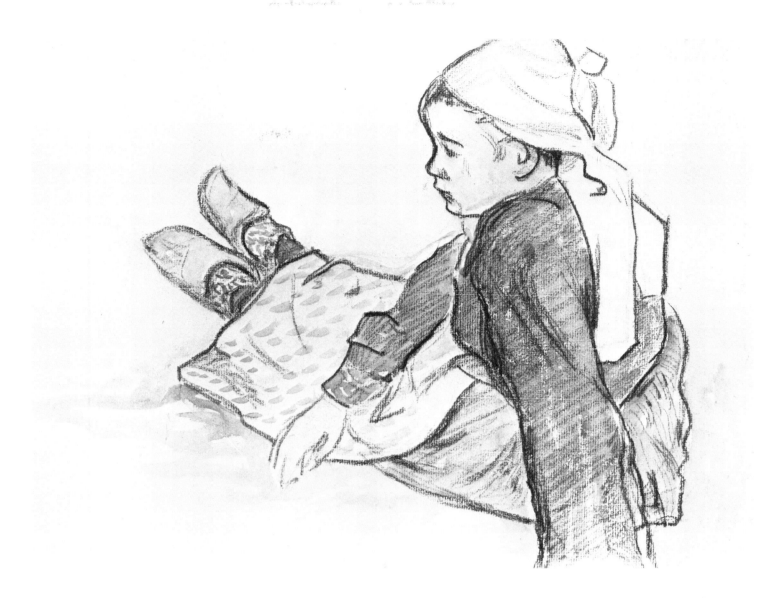

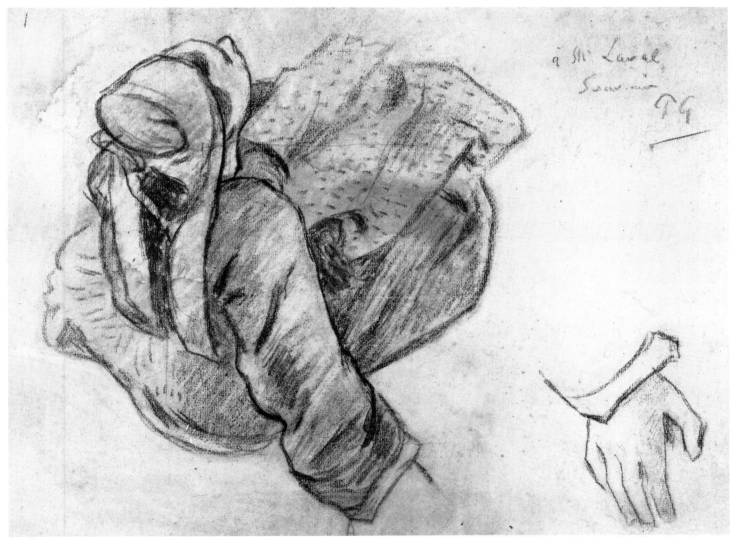

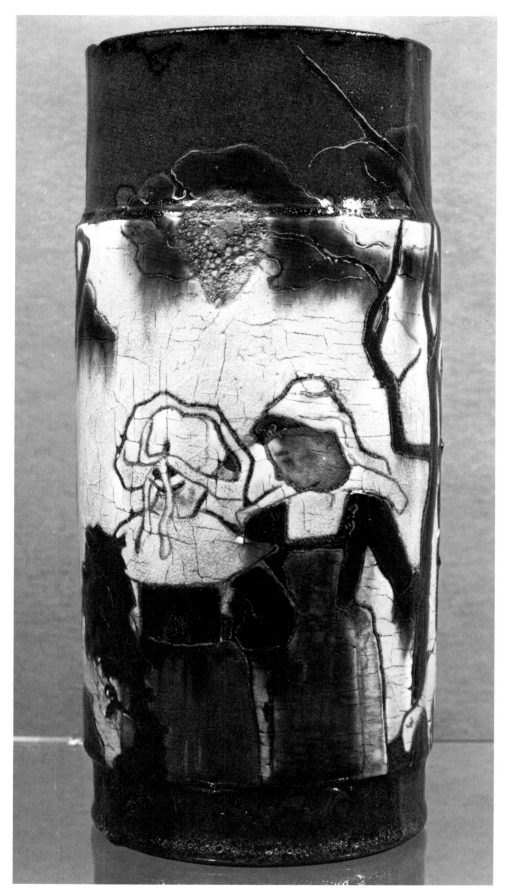 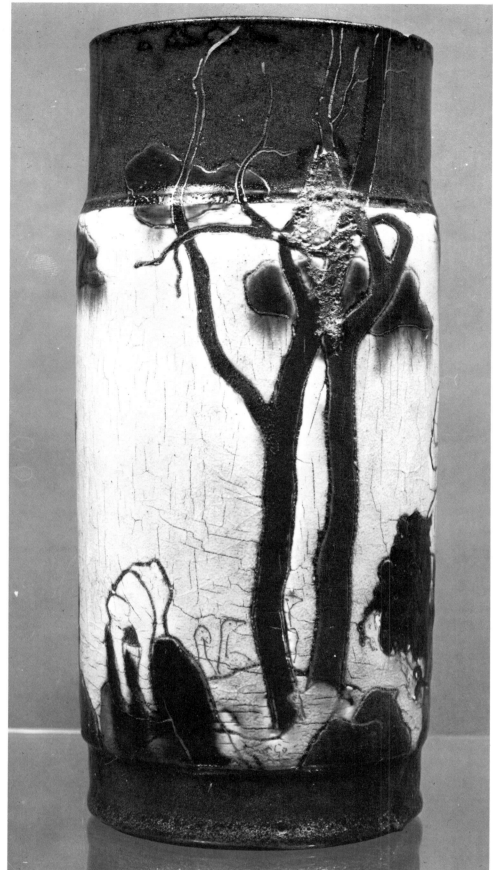

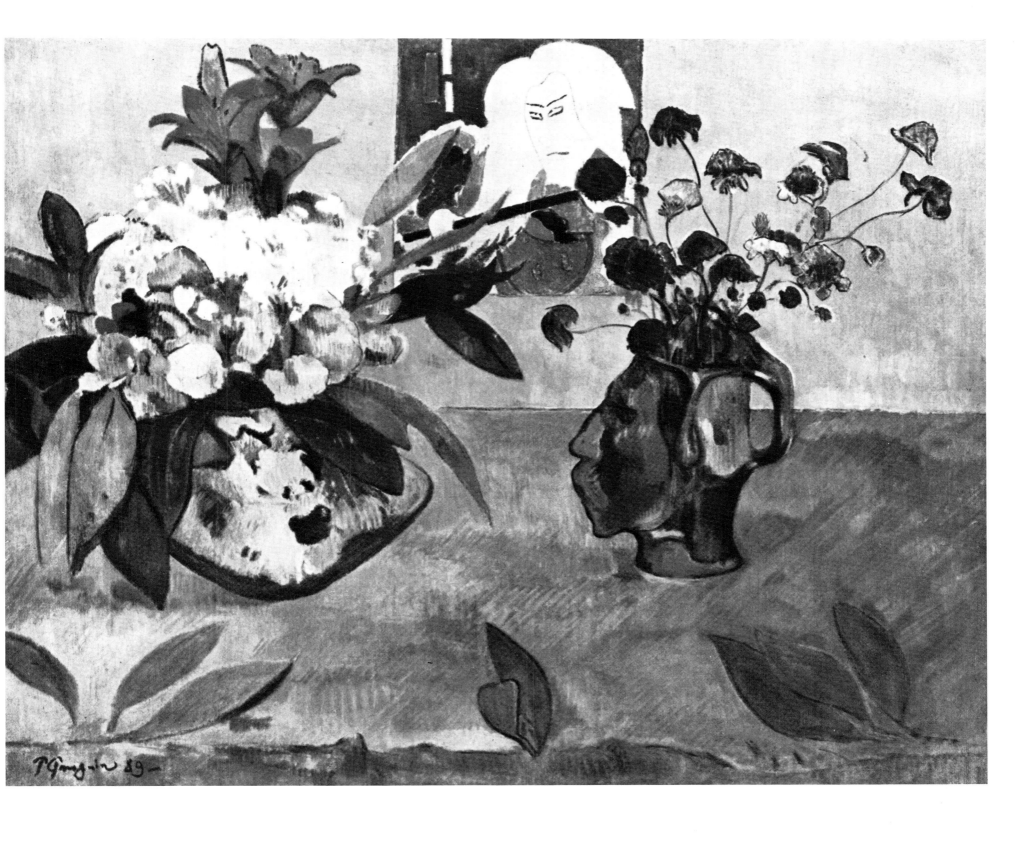

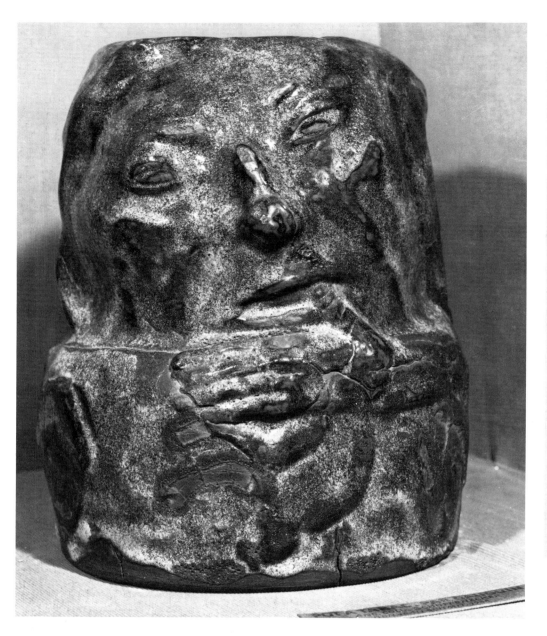
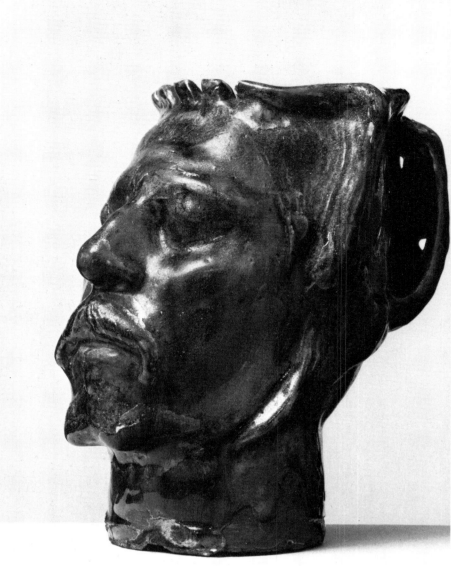
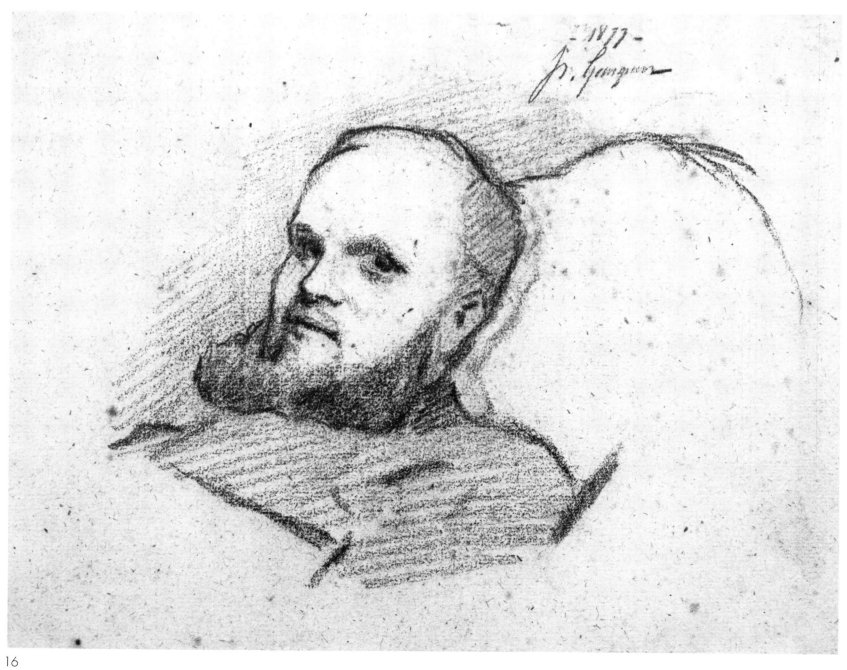

16

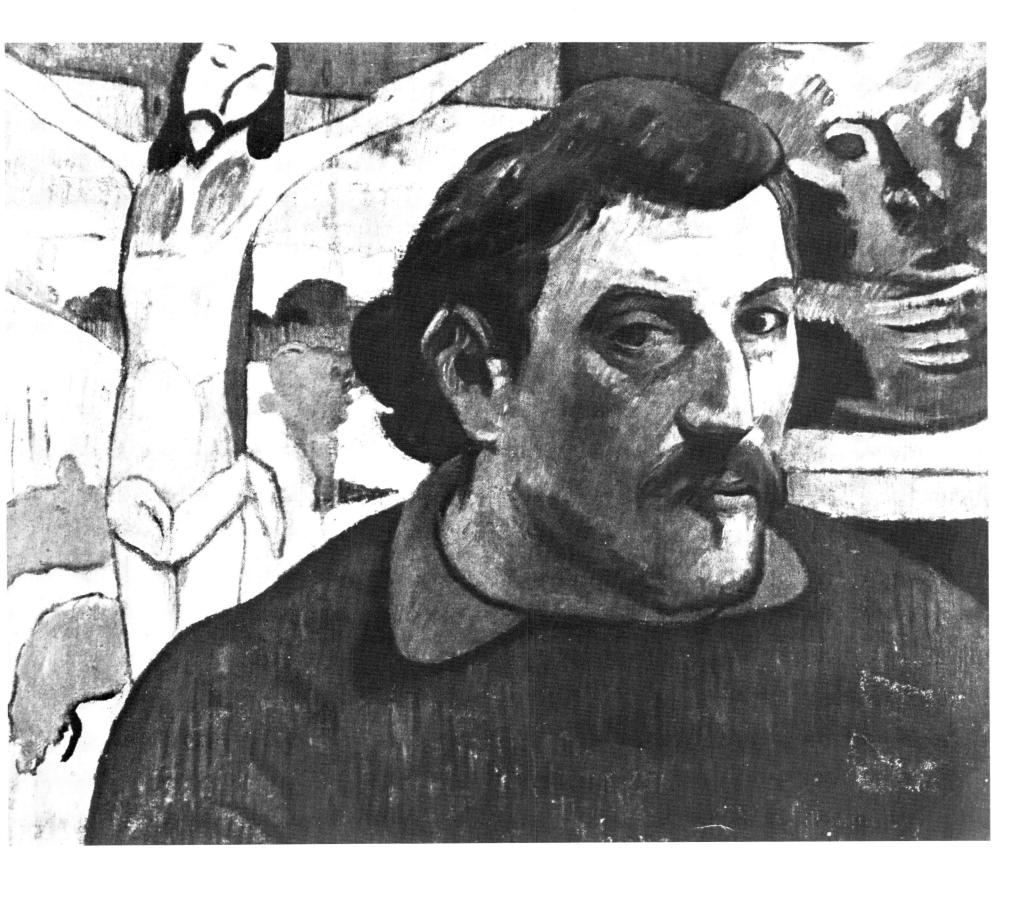

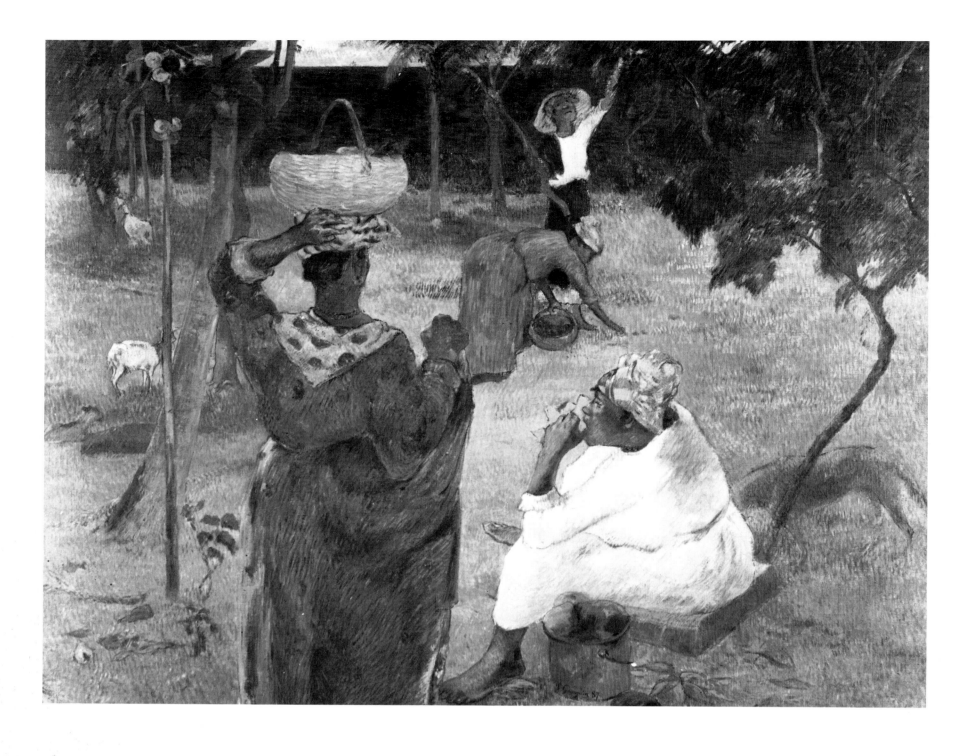

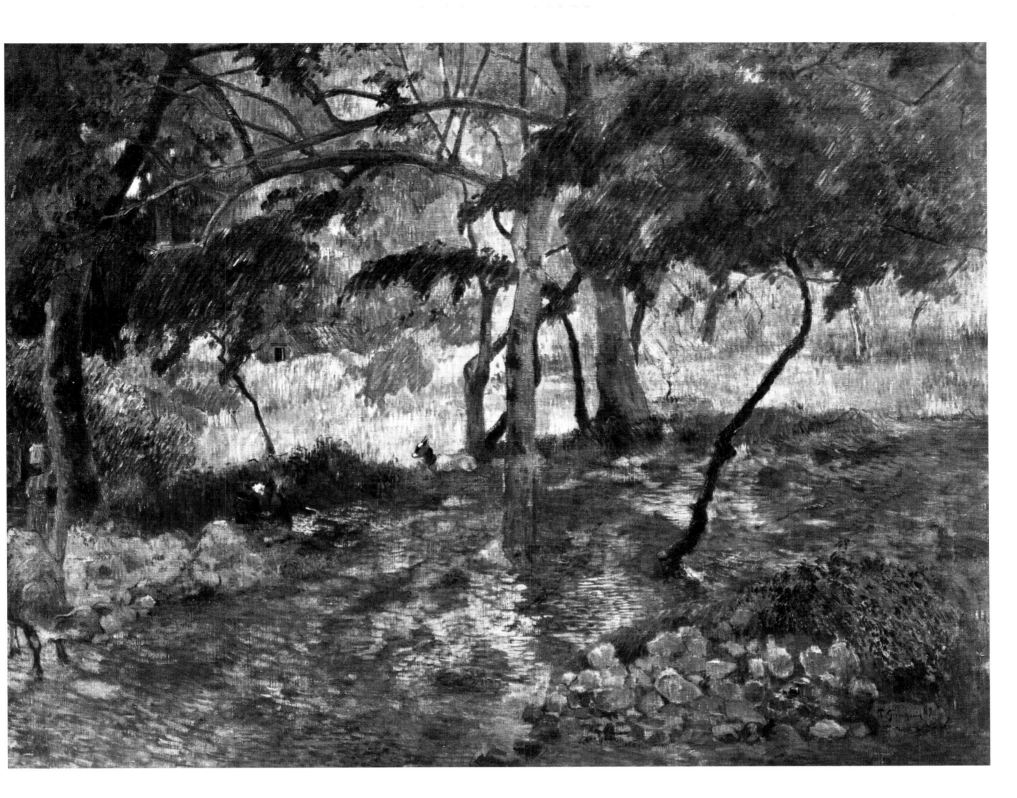

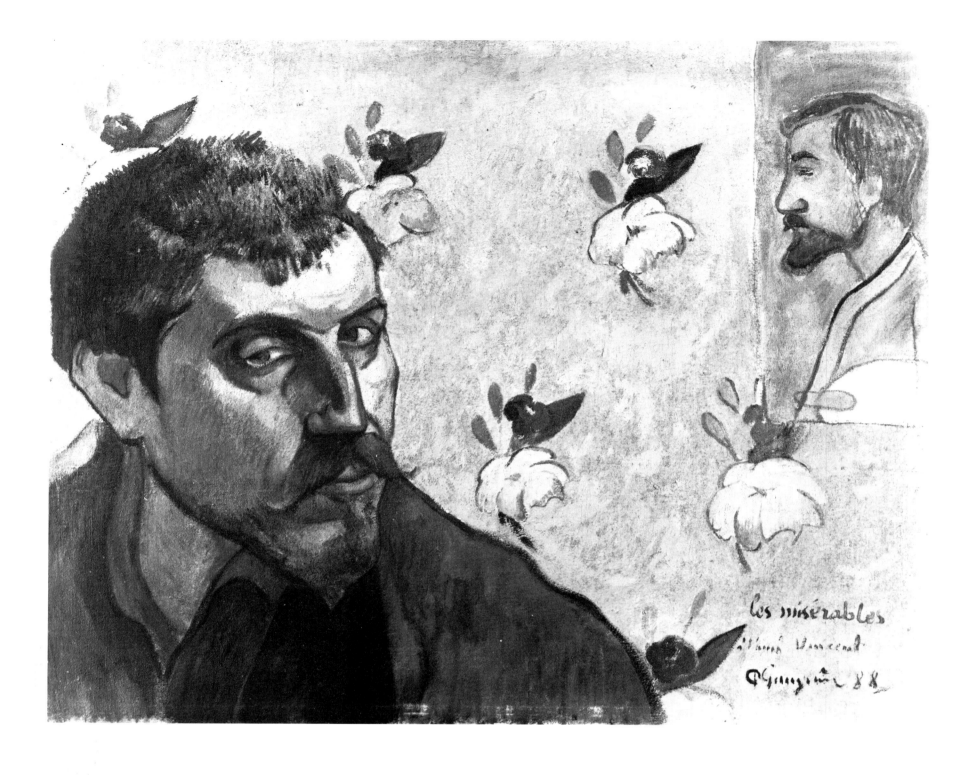

les misérables
à l'ami Vincent
P Gauguin 88

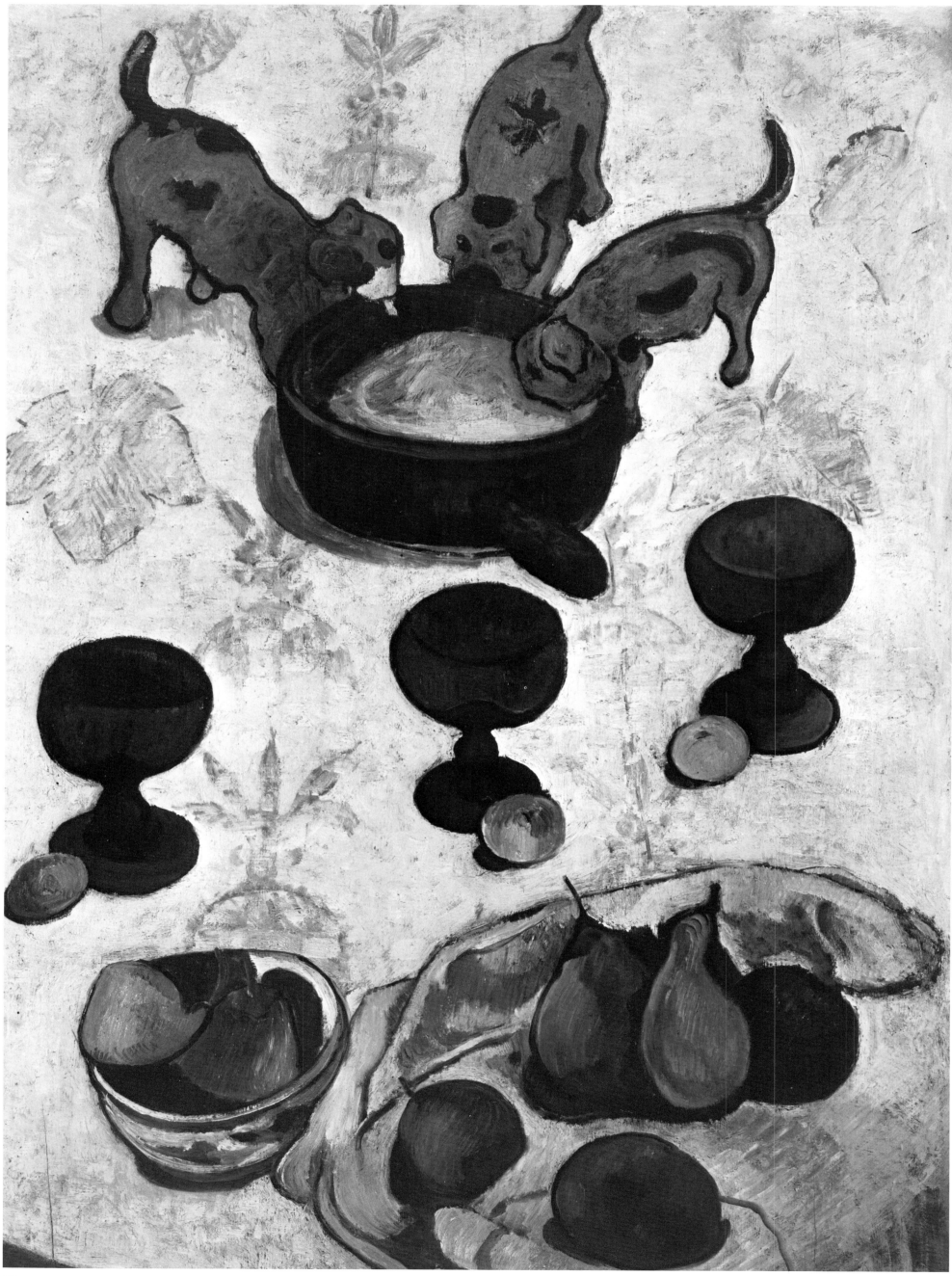

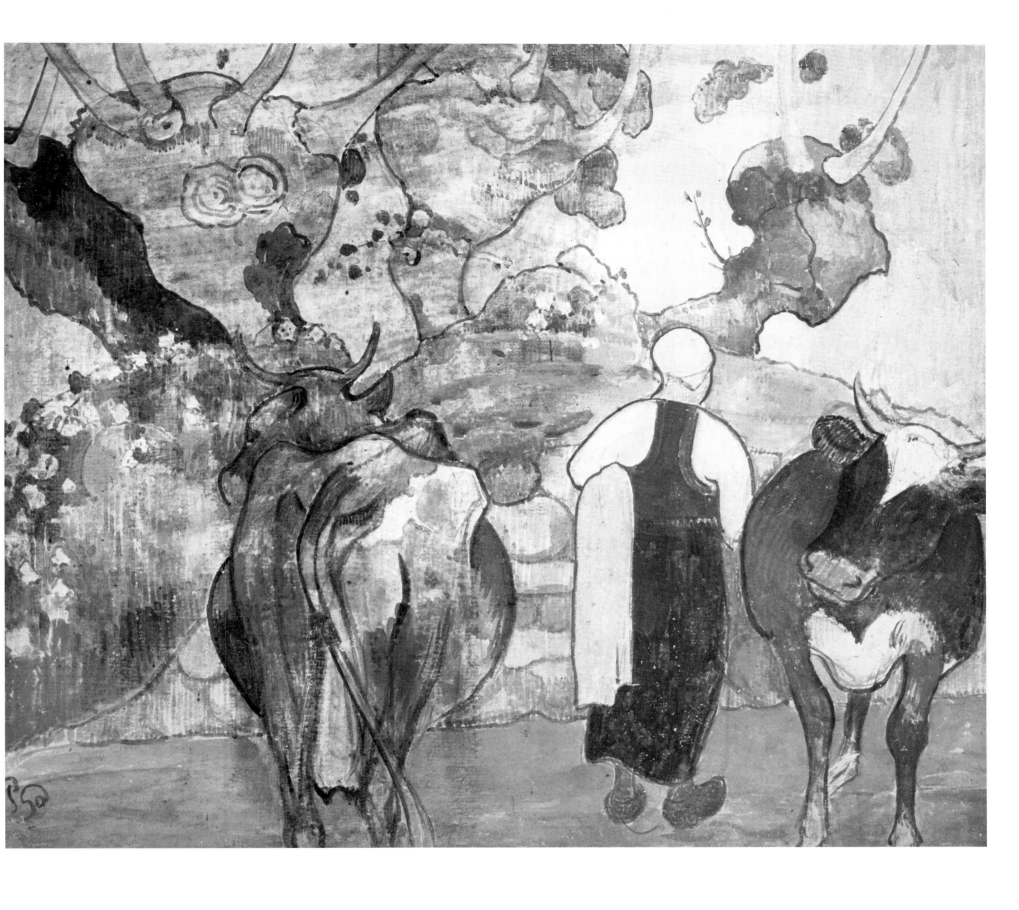

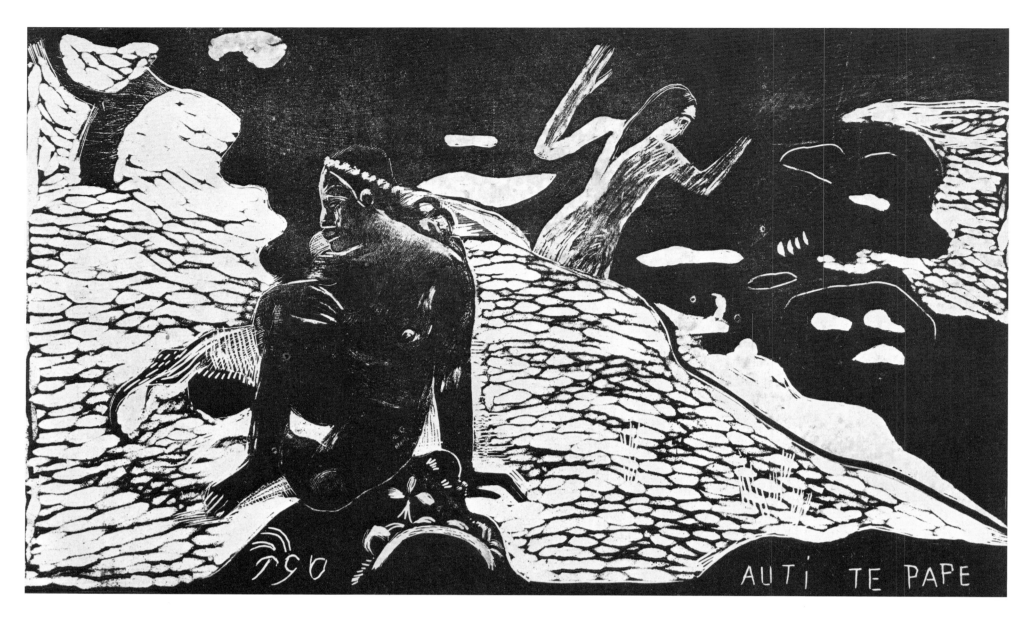

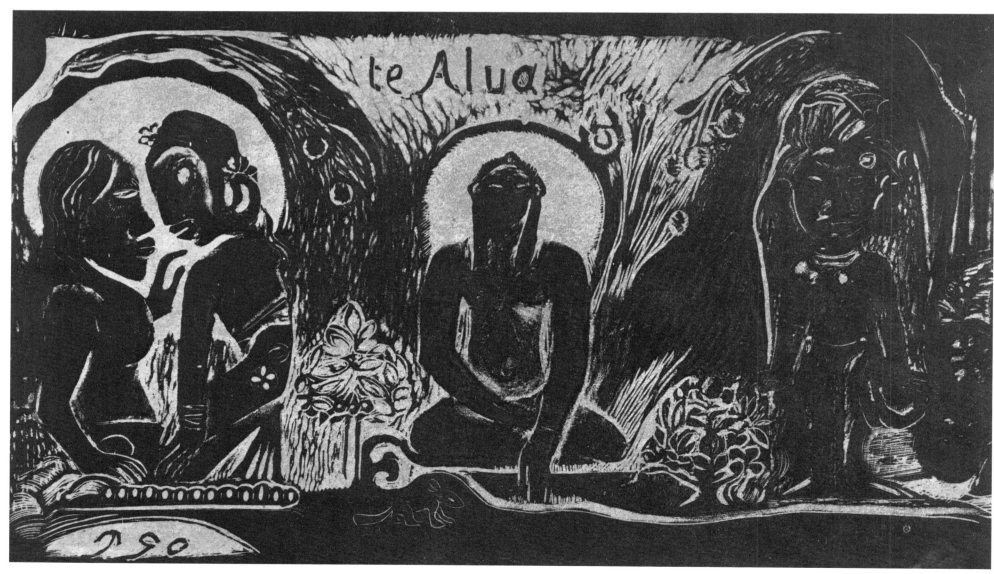

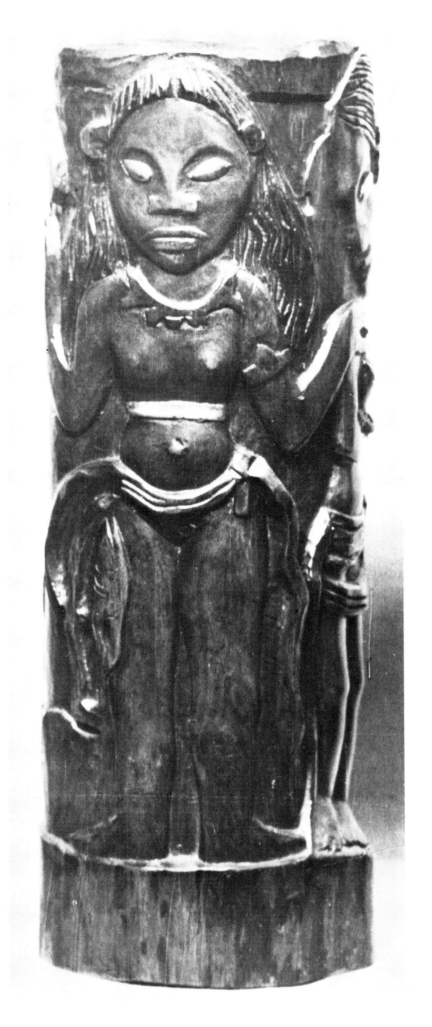 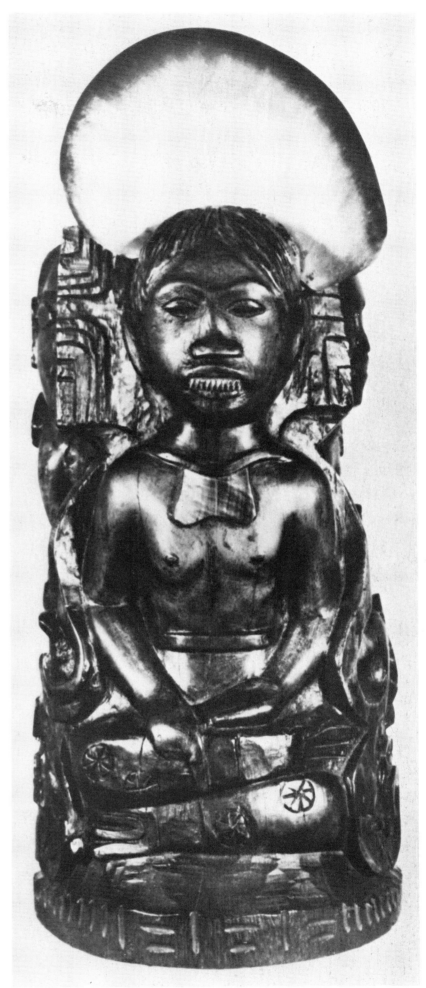

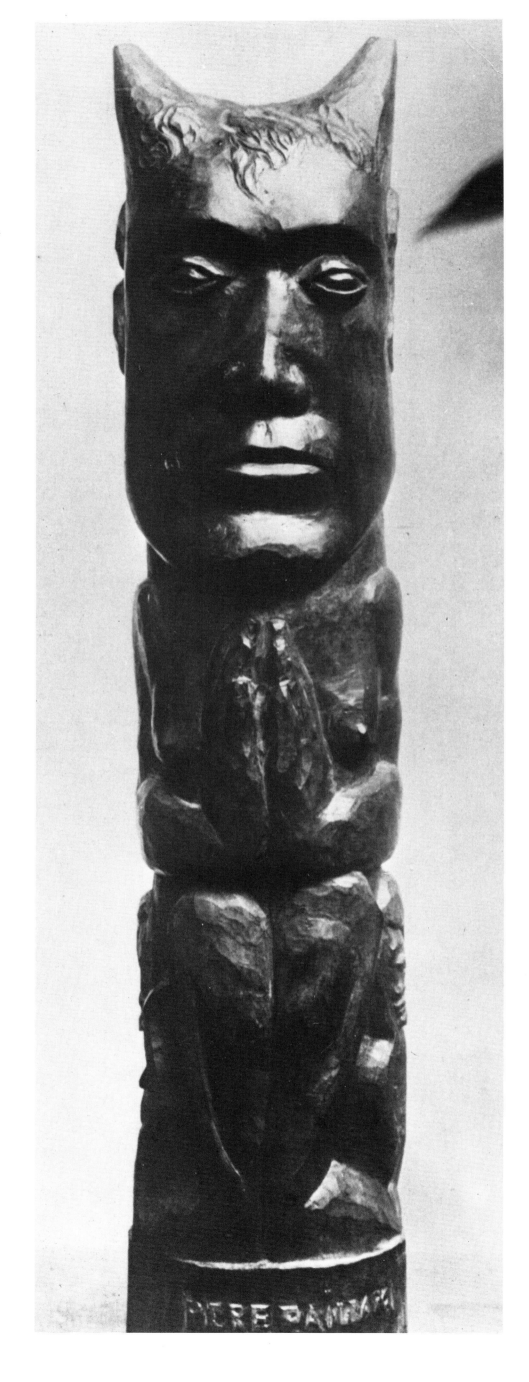

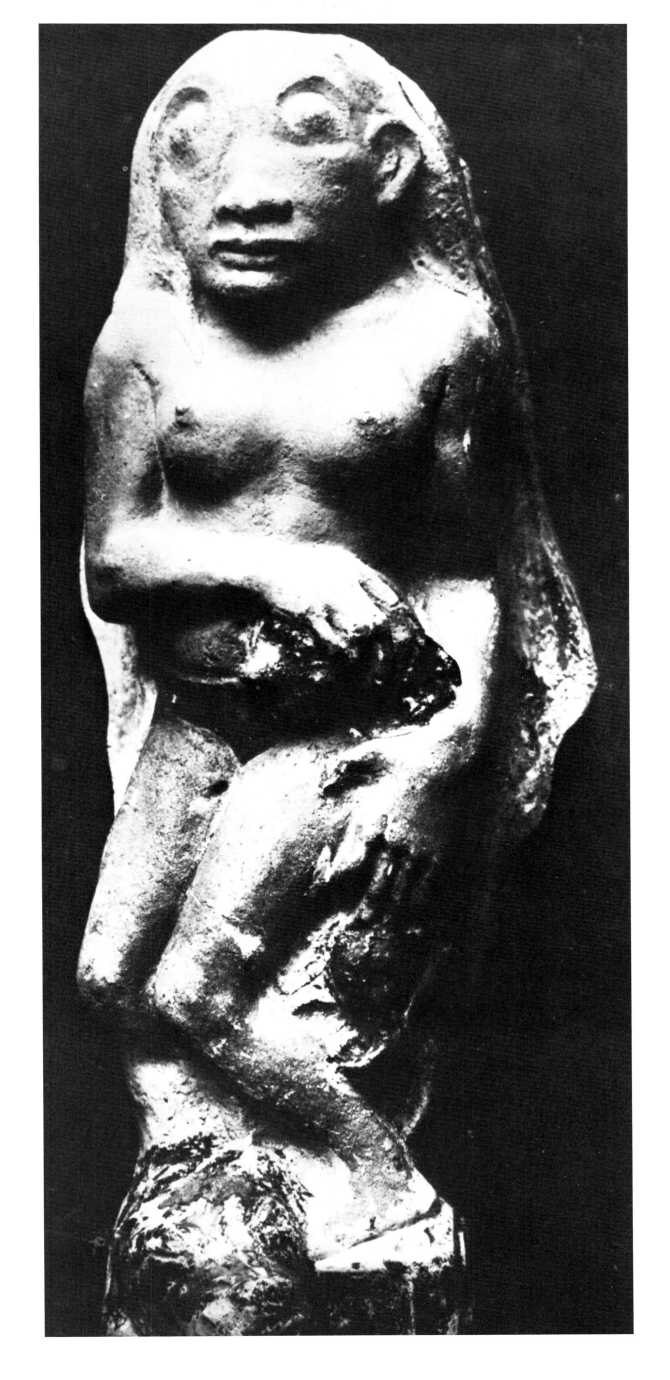

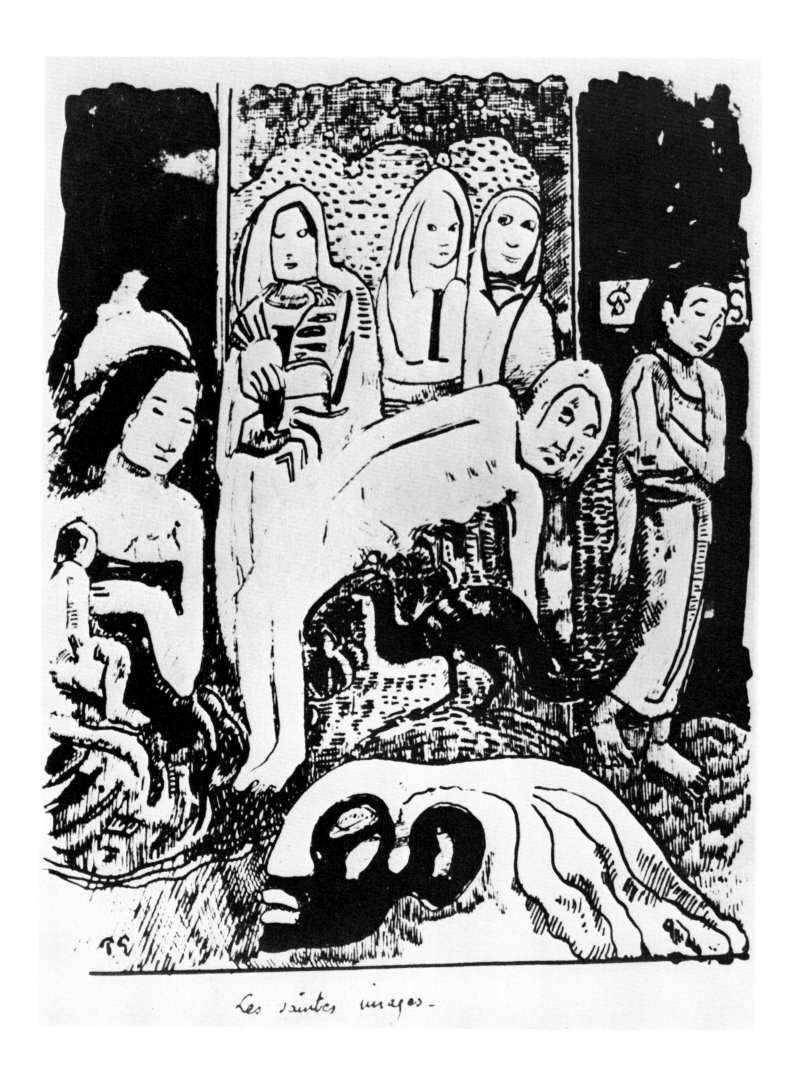

Les saintes images-

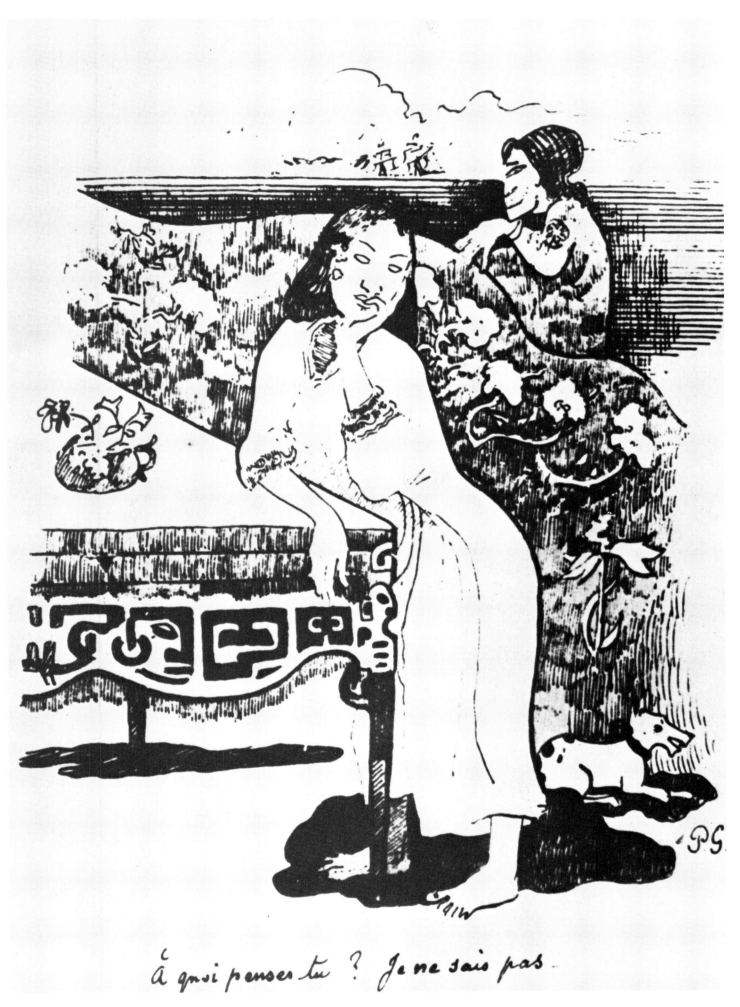

à quoi penses tu ? Je ne sais pas.

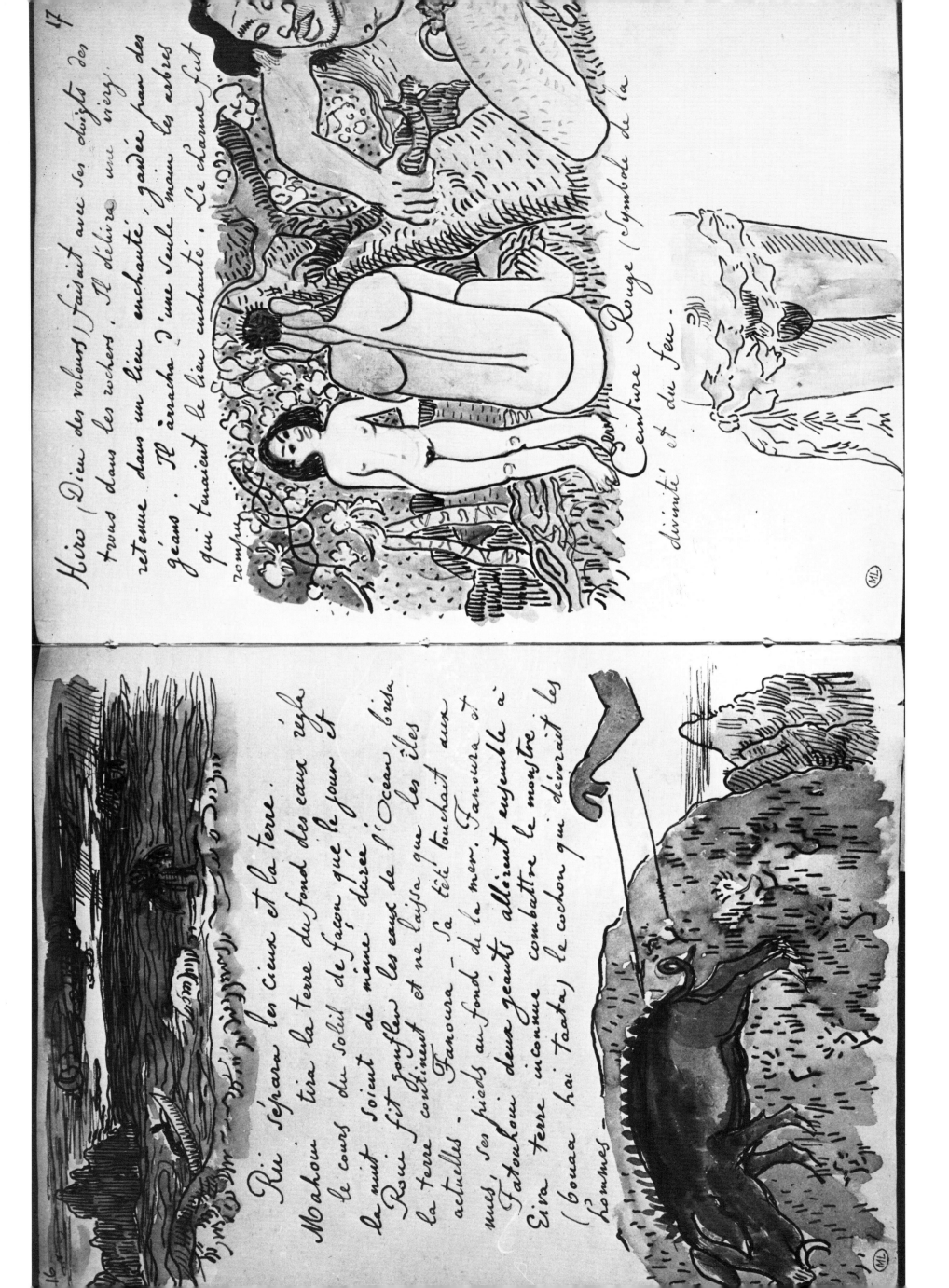

17

Hiro (Dieu des voleurs) faisait avec ses doigts des trous dans les rochers. Il délivra une vierge retenue dans un lieu enchanté. Jadis Han des géans. Il arracha d'une seule main les arbres qui tenaient le lieu enchanté. Le chemin fut rompu...

Ceinture Rouge (Symbole de la divinité et du feu.

16

Riu séprara le cieux et la terre.

Mahoui tira la terre du fond des eaux régla le cours du soleil de façon que le jour et la nuit soient de même durée.

Ruu fit gonfler les eaux de l'Océan, brisa la terre continent et ne laissa que les îles actuelles -

Fanoura - Sa tête touchait aux nues, ses pieds au fond de la mer. Fanoura et Fatoukou deux géants allaient ensemble à Eiva terre inconnue combattre le monstre (Bonaa hai taata) le cochon qui dévorait les hommes -

The Colour Plates

The Captions

33 Gauguin at his Easel
65 × 54 cm. 1885. Berne, Collection Dr. Jacques Koerfer.
W138

34 Rouen, The Blue Rooftops
74 × 60 cm. 1884. Winterthur, Collection Oskar
Reinhart. W100

35 Beach at Dieppe
71.5 × 71.5 cm. 1885. Copenhagen, Ny Carlsberg
Glyptotek. W166

36 Two Pots in Unglazed Stoneware
Jug with Medaillion. h. 24.4. About 1866–87 (G31). Jar in
the shape of a Lumpfish. h. 22 cm. 1889 (G93). Copen-
hagen, Museum of Decorative Art.

37 Still-life with Profile of Charles Laval
46 × 38 cm. 1886. Private Collection. W207

38 The Schuffenecker Family
73 × 92 cm. 1889. Paris, Jeu de Paume. W313

39 Tropical Vegetation
116 × 89 cm. 1887. Edinburgh, National Gallery of
Scotland. W232

40 Vision after the Sermon (Jacob Wrestling
with the Angel)
73 × 92 cm. 1888. Edinburgh, National Gallery of
Scotland. W245

41 Human Anguish (Vintage at Arles)
73 × 92 cm. 1888. Museum of Ordrupgaard, Wilhelm
Hausen Collection. W304

42 The Yellow Christ
92 × 73 cm. 1889. Buffalo, Albright Knox Art Gallery.
W327

43 Breton Calvary (The Green Christ)
92 × 73 cm. 1889. Brussels, Musées Royaux des Beaux
Arts de Belgique. W328

44 Bonjour Monsieur Gauguin
113 × 92 cm. 1889. Prague, Narodni Galerie. W322

45 Self-portrait
Oil on wood, 80 × 52 cm. 1889. Washington, National
Gallery of Art. W323

46 Christ in the Garden of Olives
73 × 92 cm. 1889. Palm Beach, Norton Gallery and
School of Fine Art. W326

47 The Meal (The Bananas)
73 × 92 cm. 1891. Paris, Jeu de Paume. W427

48 Soyez Amoureuses et Vous Serez Heureuses
(Be in Love and You Will Be Happy)
Carved and painted wood, 97 × 75 cm. 1889. Boston,
Museum of Fine Art. G76

49 Self-portrait (Oviri)
Bronze relief, 36 × 34 × 5 cm. About 1893. London, Col-
lection A.S. Teltsch. G109

50 Day of the God (Mahana No Atua)
70 × 91 cm. 1894. Chicago, Art Institute. W513

51 Loss of Virginity
90 × 130 cm. About 1890. Collection Walter
J. Chrysler. W412

52 Woman with a Flower (Vahine No Te Tiare)
70 × 46 cm. 1891. Copenhagen, Ny Carlsberg
Glyptotek. W420

53 We Greet Thee Mary (Ia Orana Maria)
114 × 89 cm. 1891. New York, Metropolitan Museum
of Art. W428

54 The Market (Ta Matete)
73 × 92 cm. 1892. Basle, Kunstmuseum. W476

55 The Spirit of the Dead keeps Watch (Manao
Tupapao)
73 × 92 cm. 1892. Buffalo, Albright Knox Art Gallery.
W457

56 And The Gold of Their Bodies
67 × 76 cm. 1901. Paris, Jeu de Paume. W596

57 Anna the Javanese (Aita Tamari Vahina Judith
Te Parari)
116 × 81 cm. 1893. Berne, Hahnloser Collection. W508

58 Breton Girl Praying
65 × 46 cm. 1894. England, Collection Mrs McRoberts.
W518

59 Fragrance (Noa Noa)
Woodcut, 35 × 20 cm. 1891–93. New York, Museum of
Modern Art (Lillie P. Bliss Collection).

**60 D'Ou Venons-Nous? Que Sommes-Nous? Ou
Allons-Nous?** (Where Do We Come From? What Are
We? Where Are We Going?)
139 × 375 cm. 1897. Boston, Museum of Fine Art. W561

61 Pastorale (Faa Iheihe)
54 × 169 cm. 1898. London, Tate Gallery. W569

62 L'Appel (The Call)
130 × 89 cm. 1902. Cleveland, Ohio, Museum of Art.
W612

63 Contes Barbares (Barbaric Tales)
130 × 89 cm. 1902. Essen, Folkwang Museum. W625

64 Nevermore
60 × 116 cm. 1897. London, Courtauld Institute Galleries.
W558

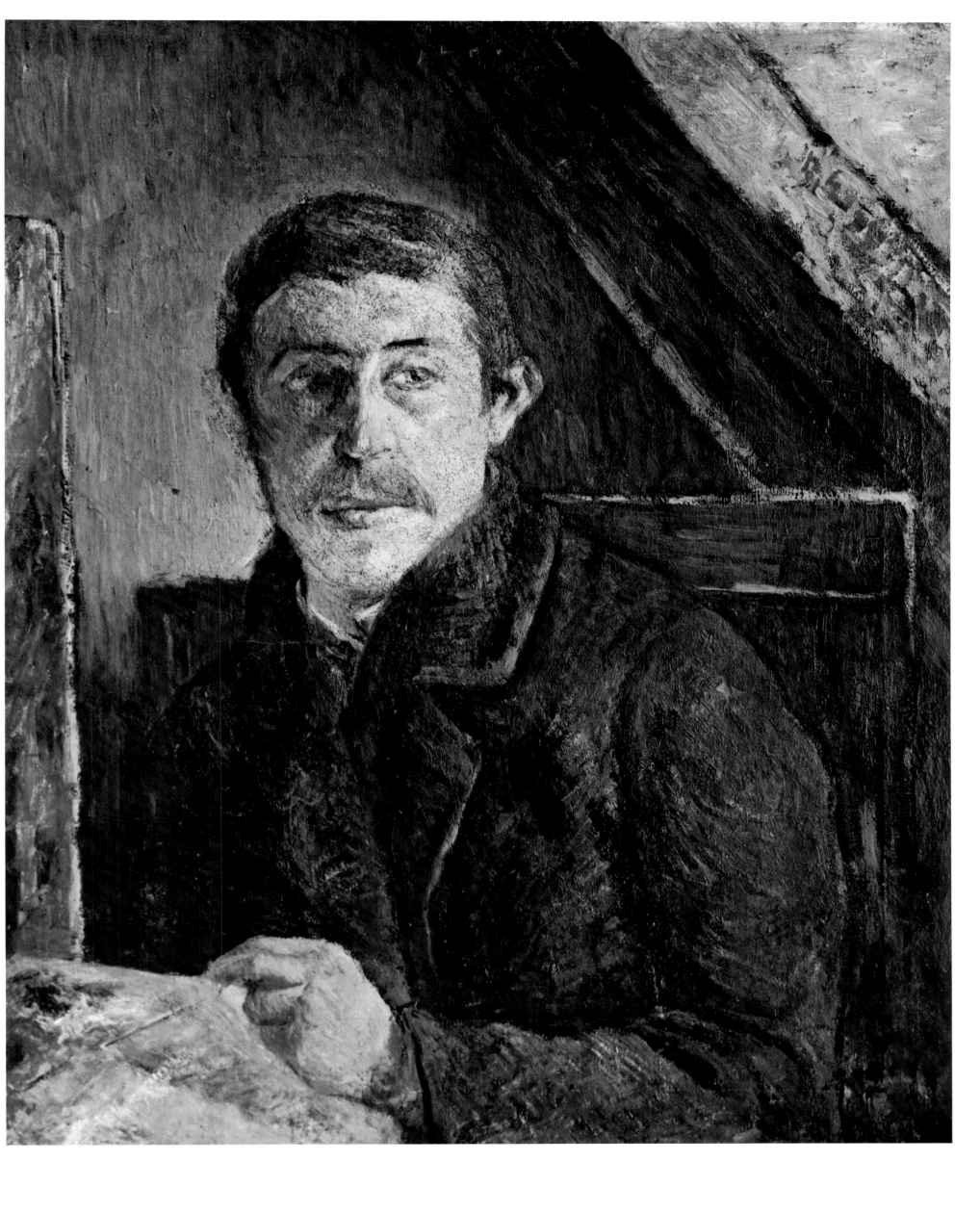

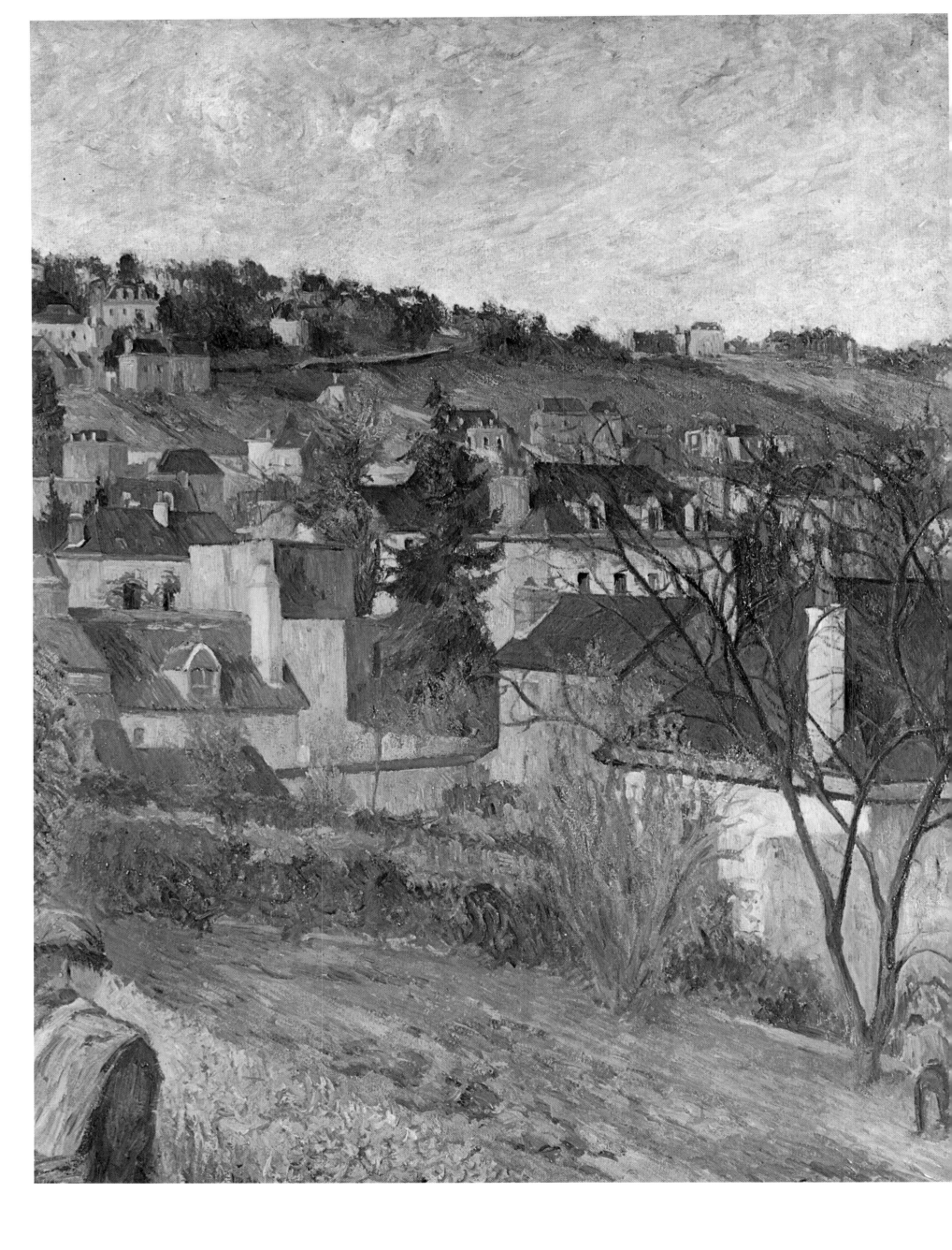

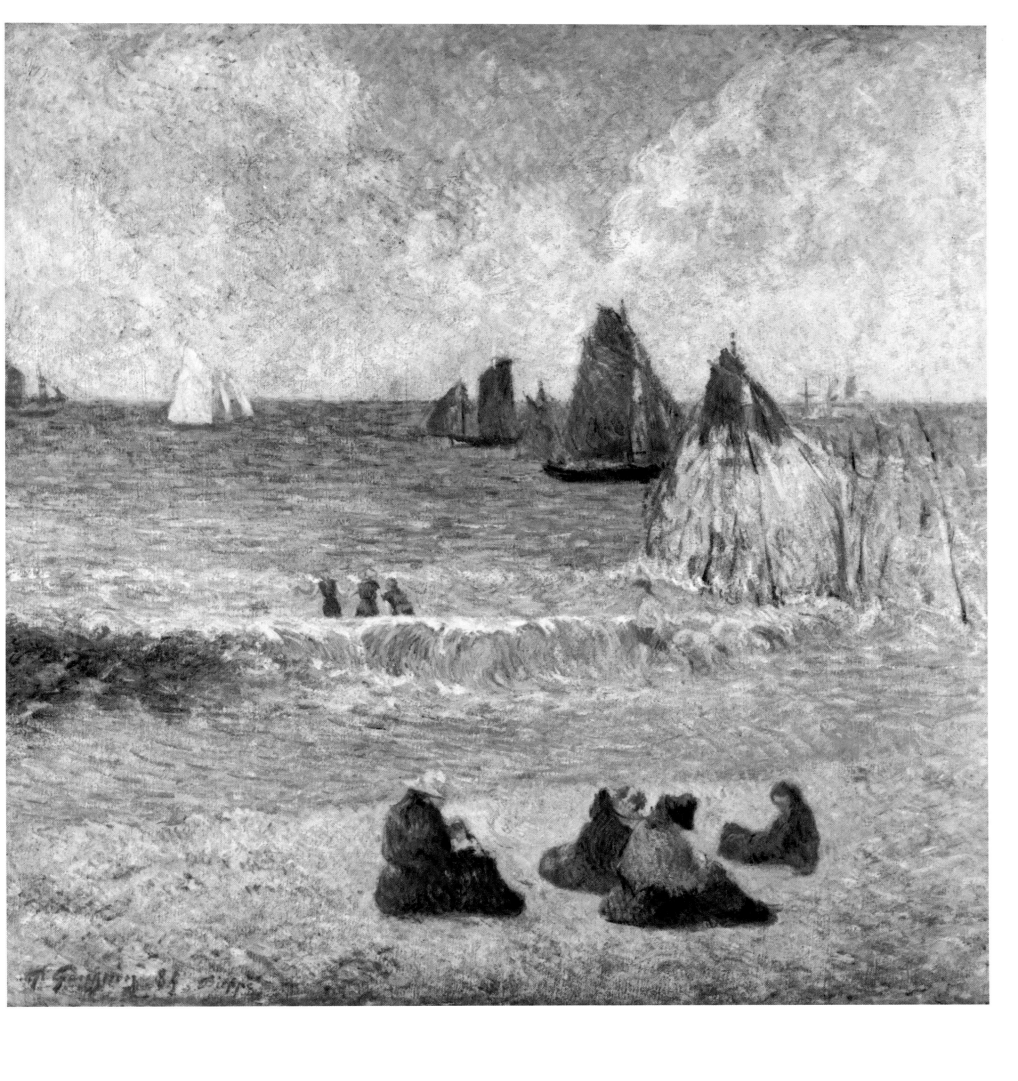

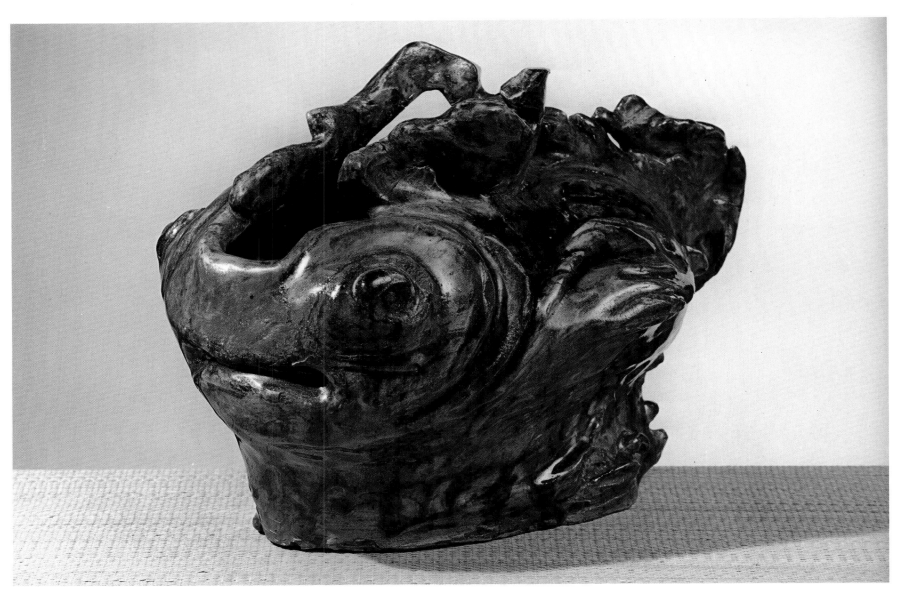

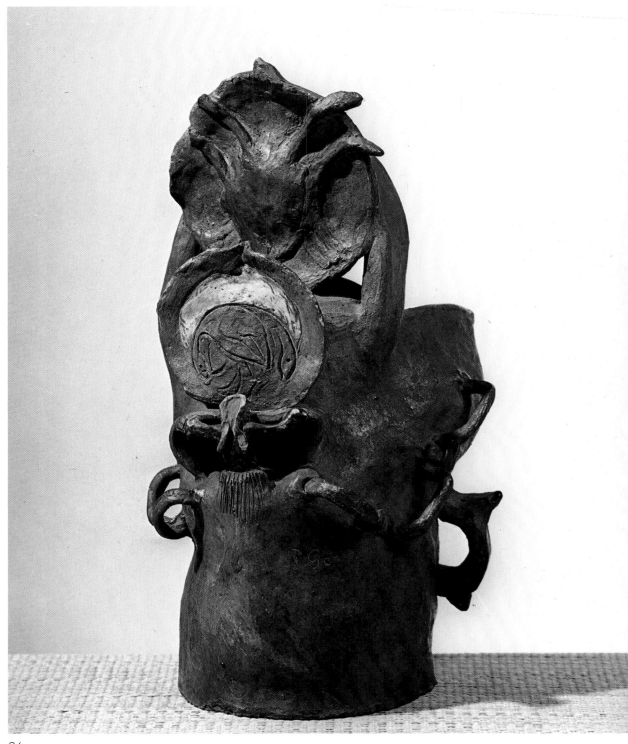

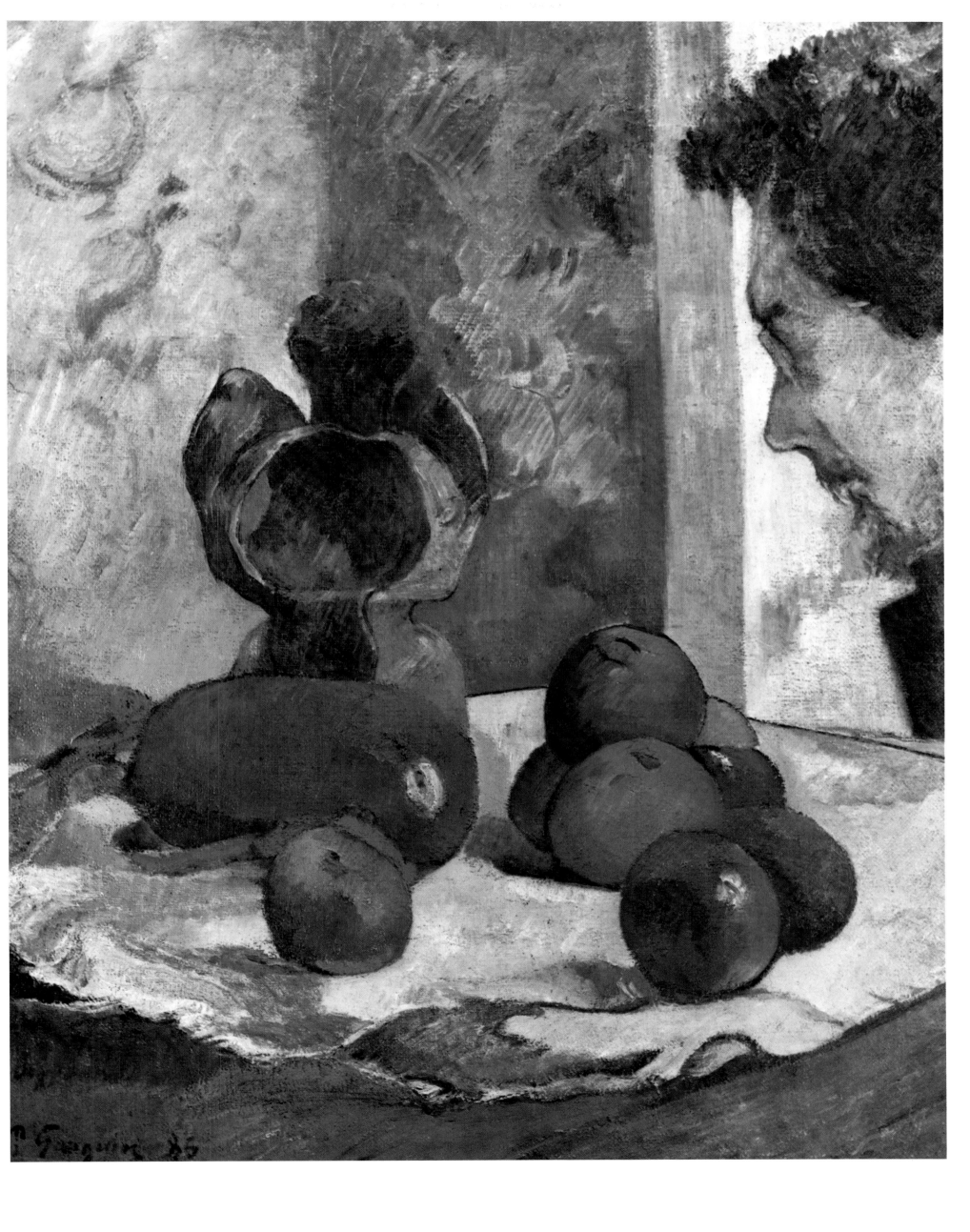

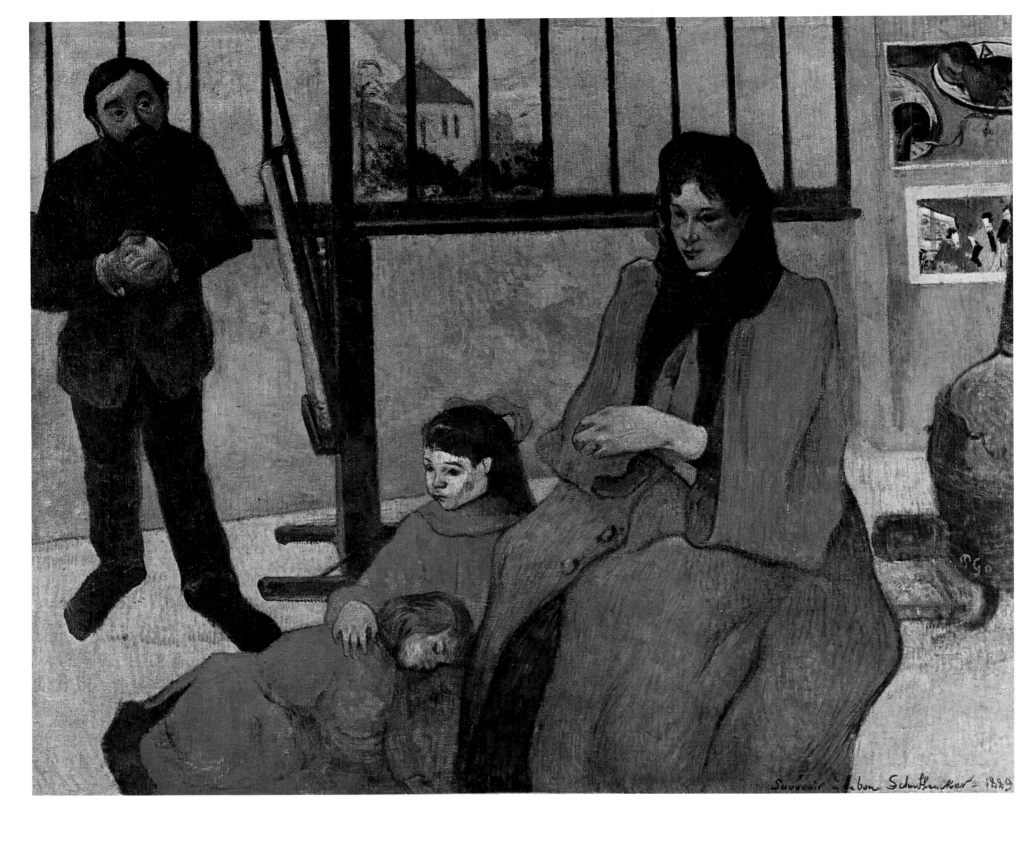

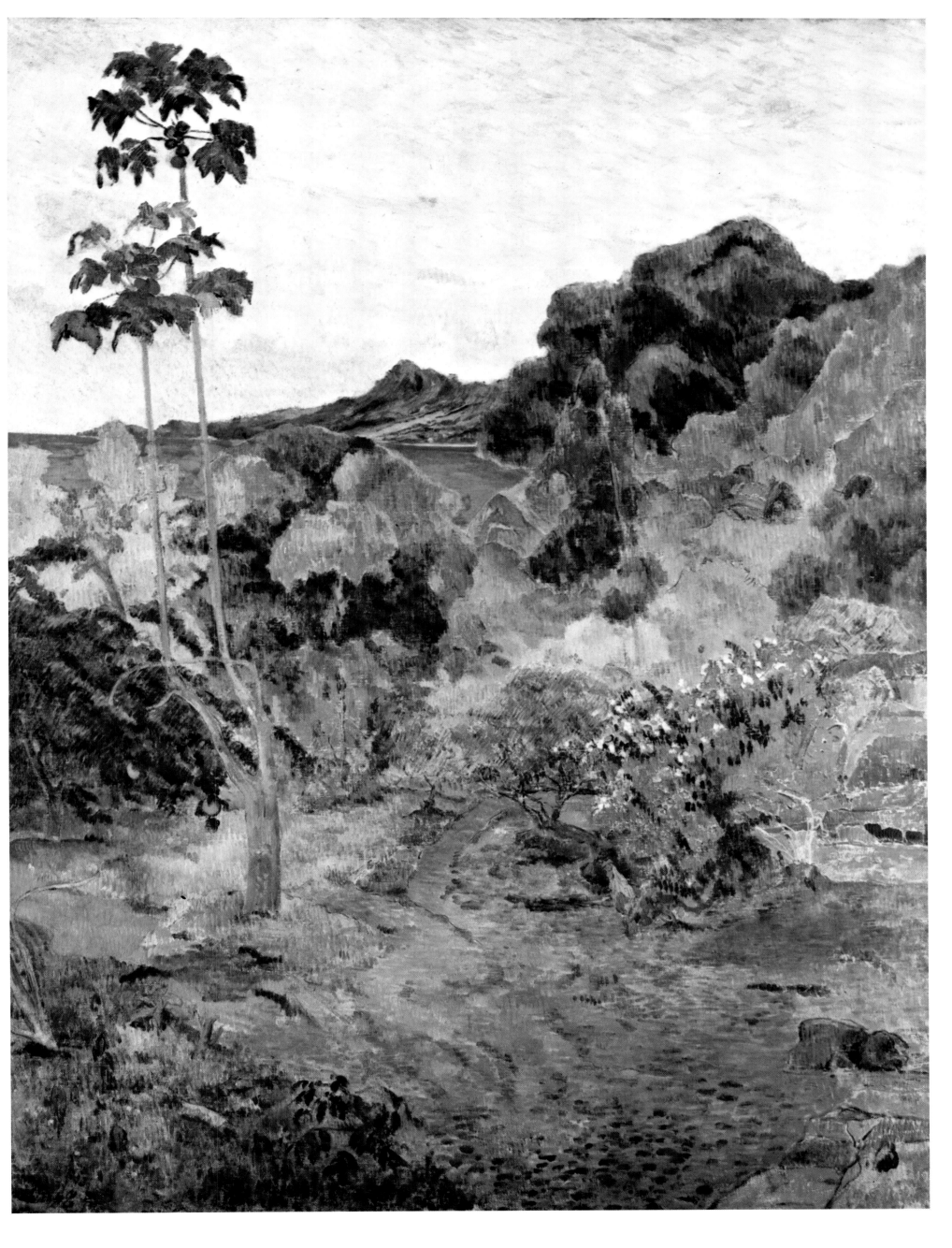

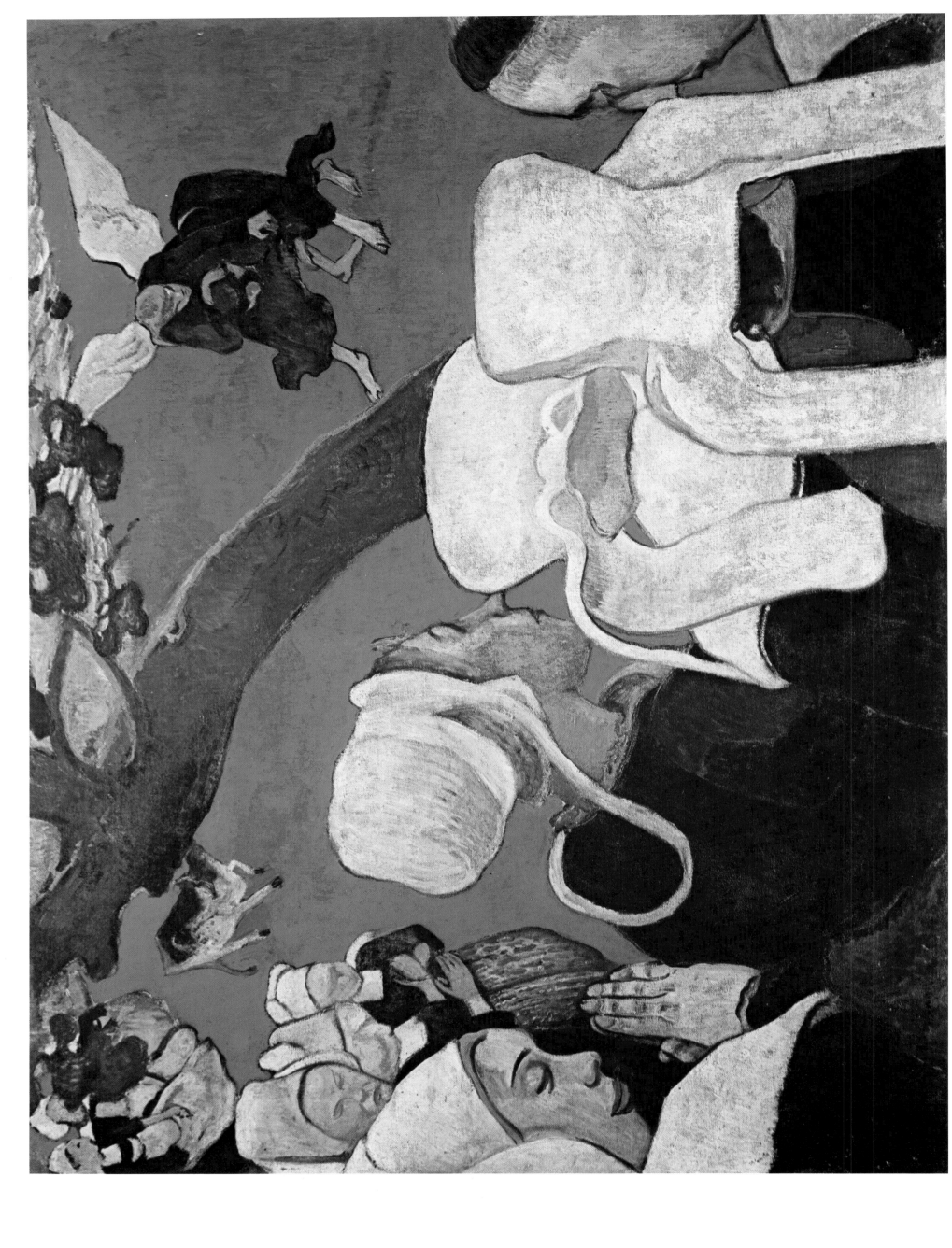

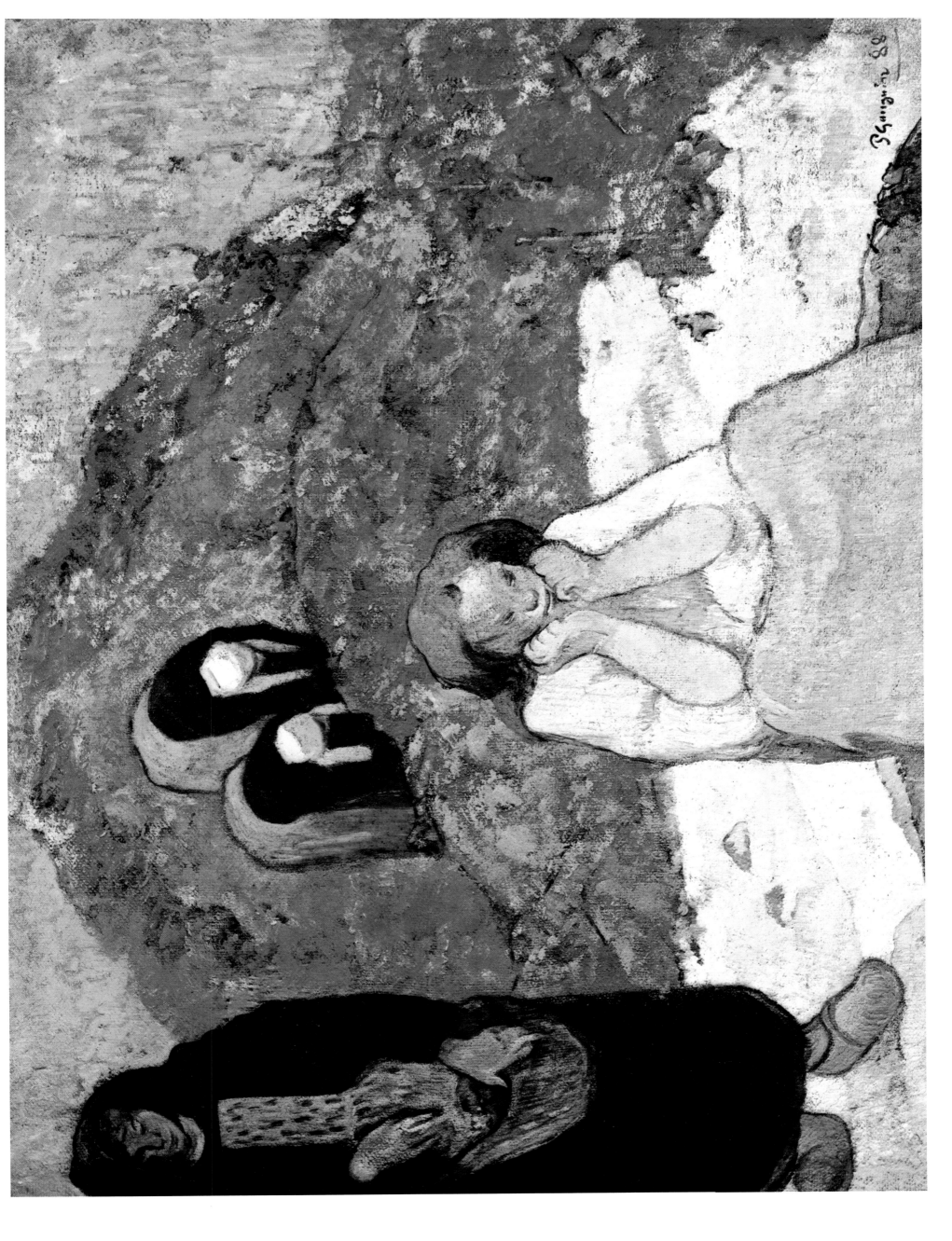

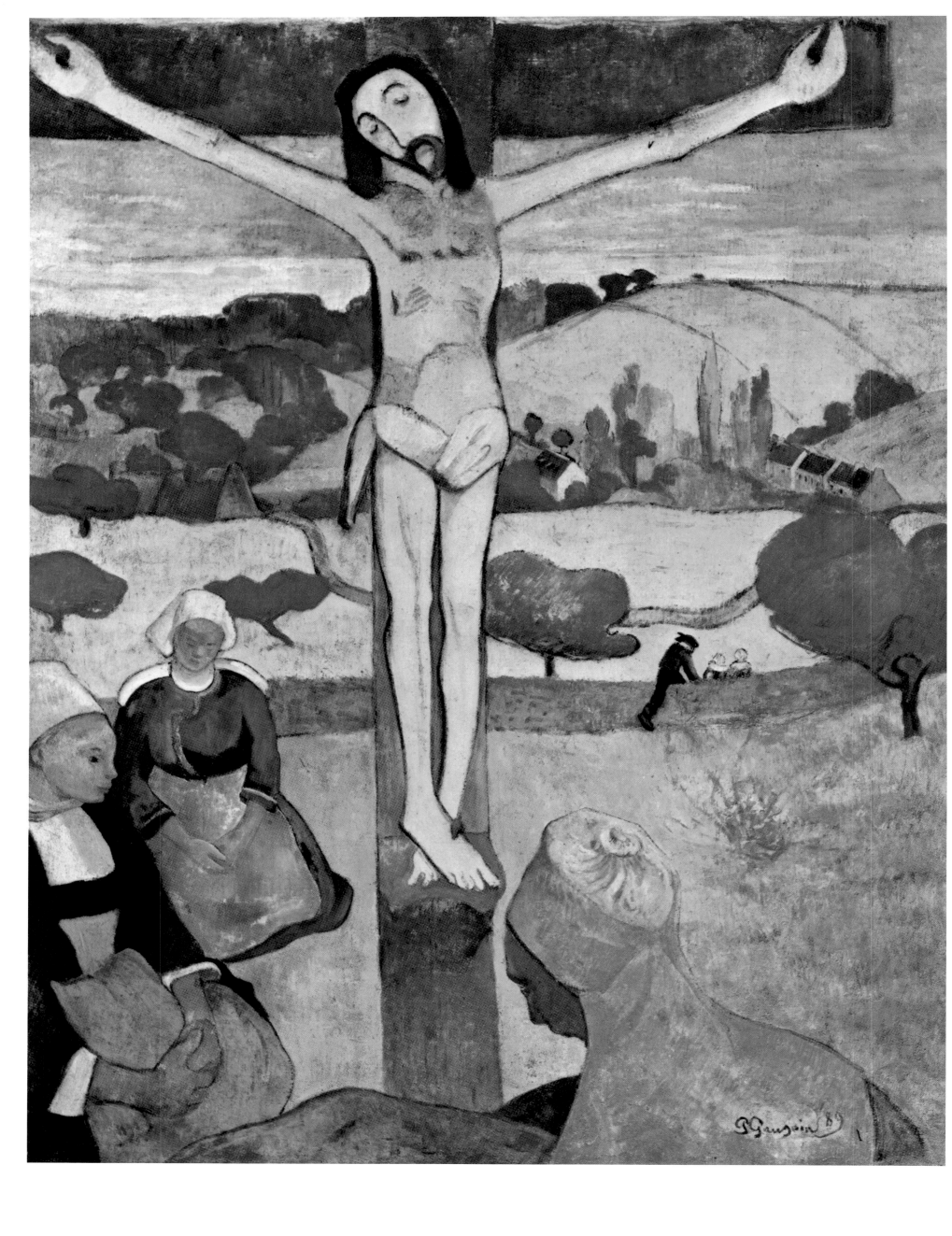

42

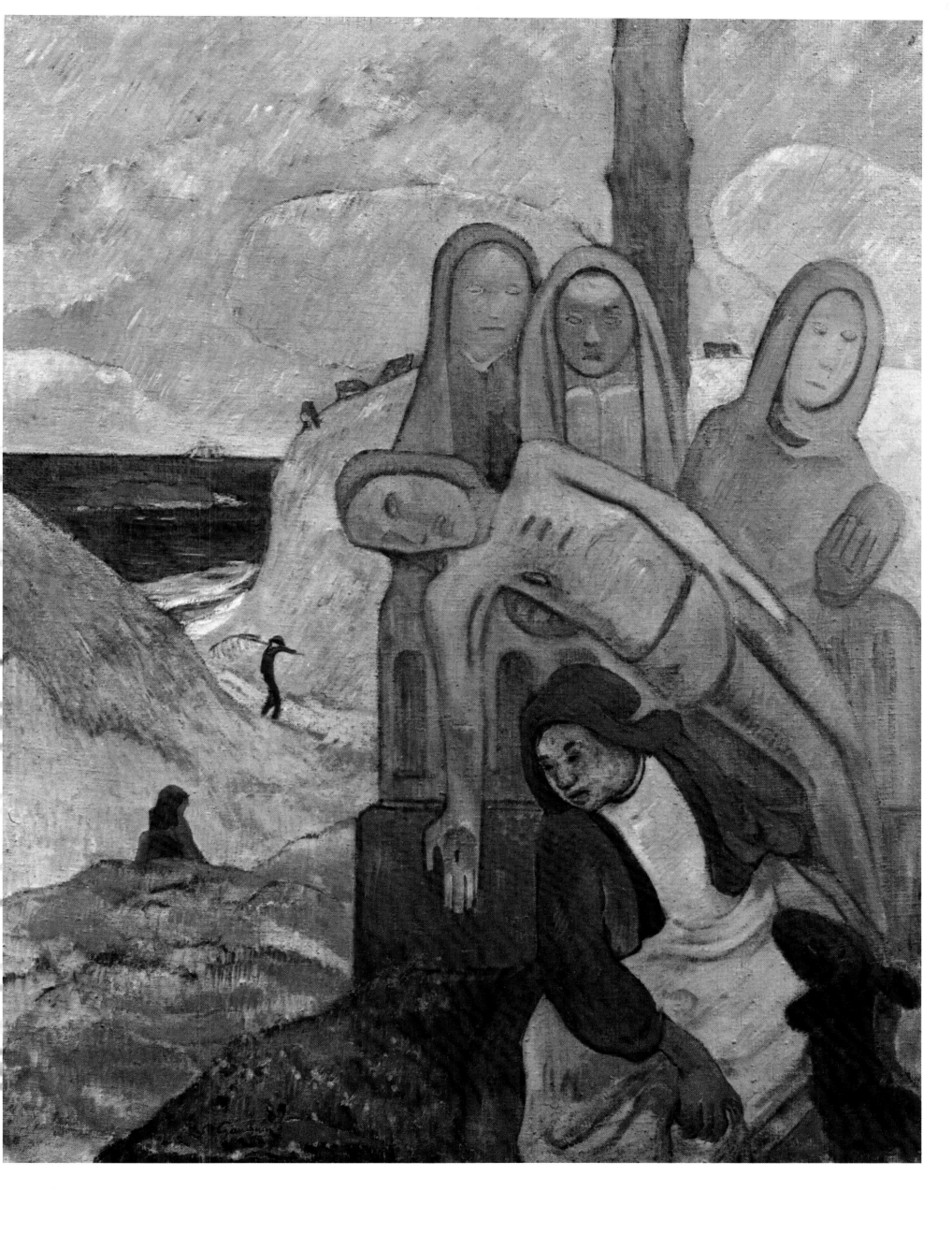

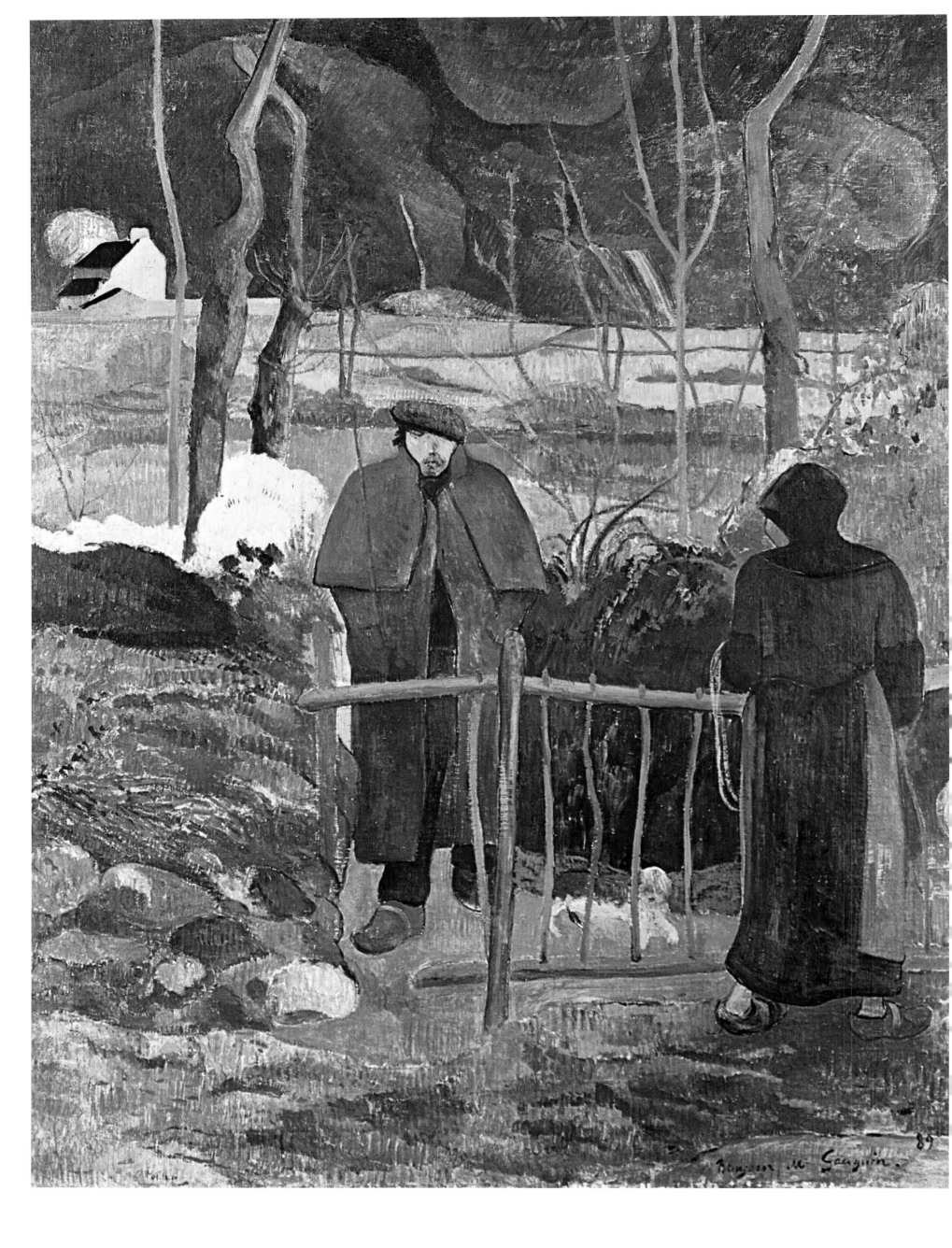

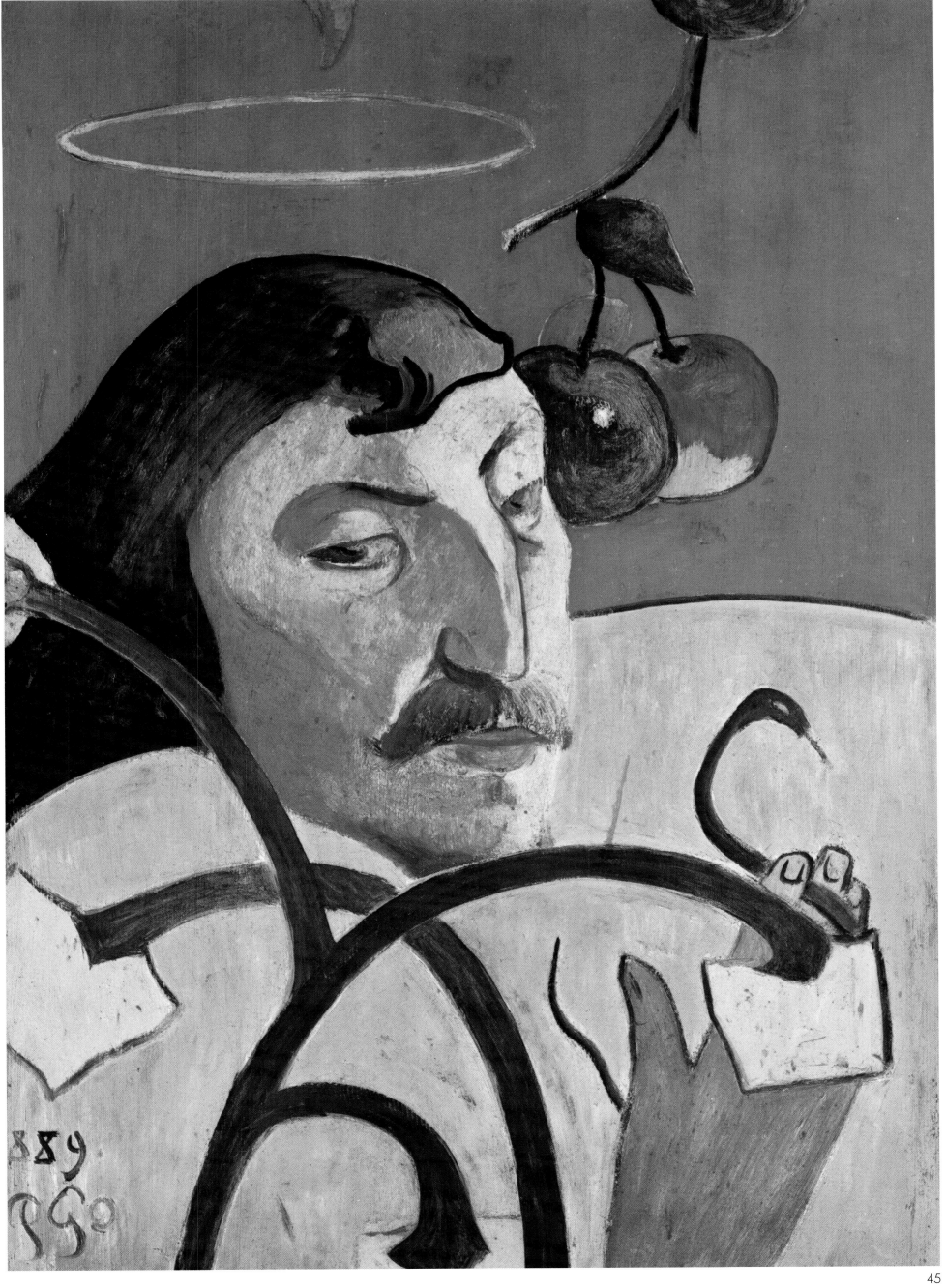

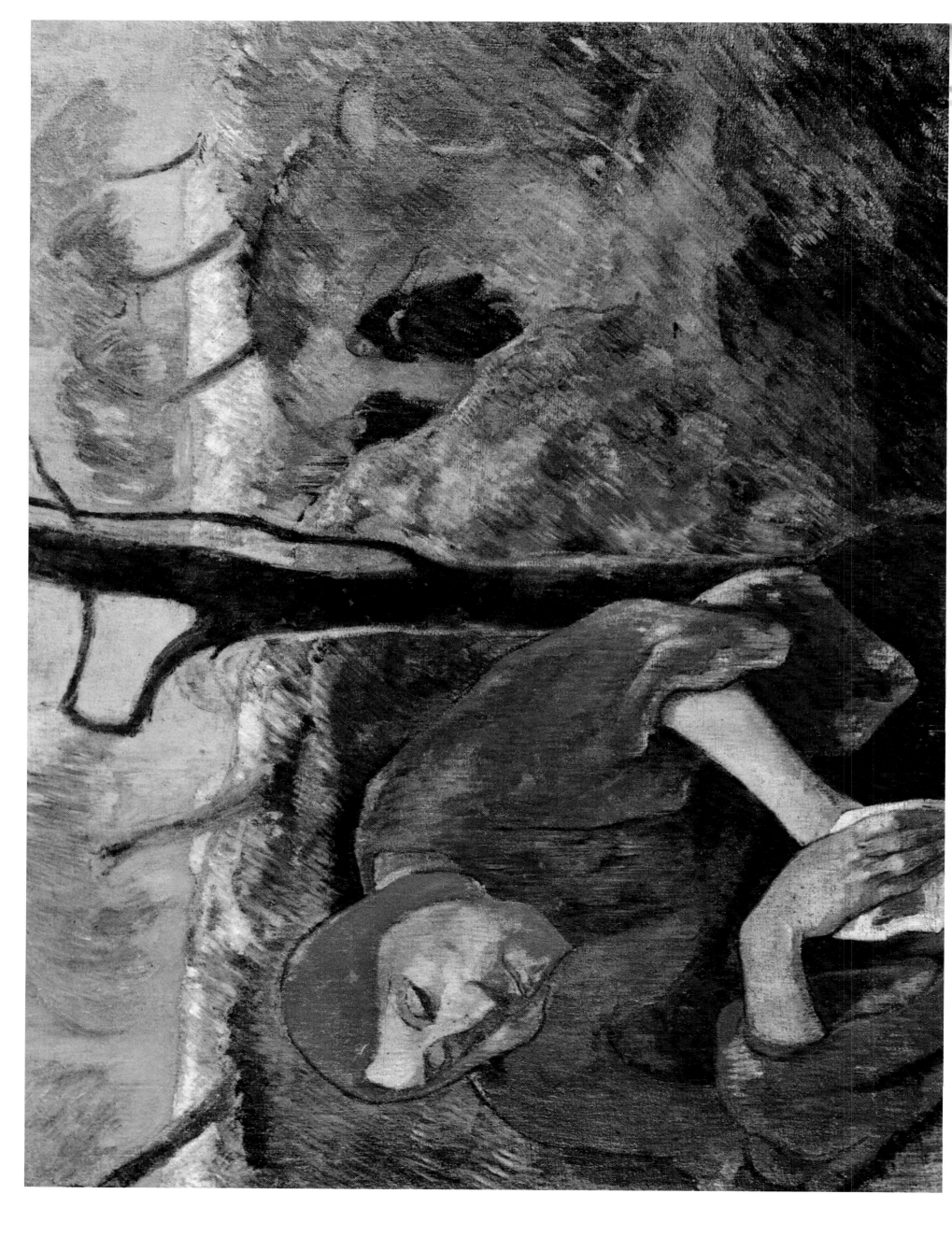

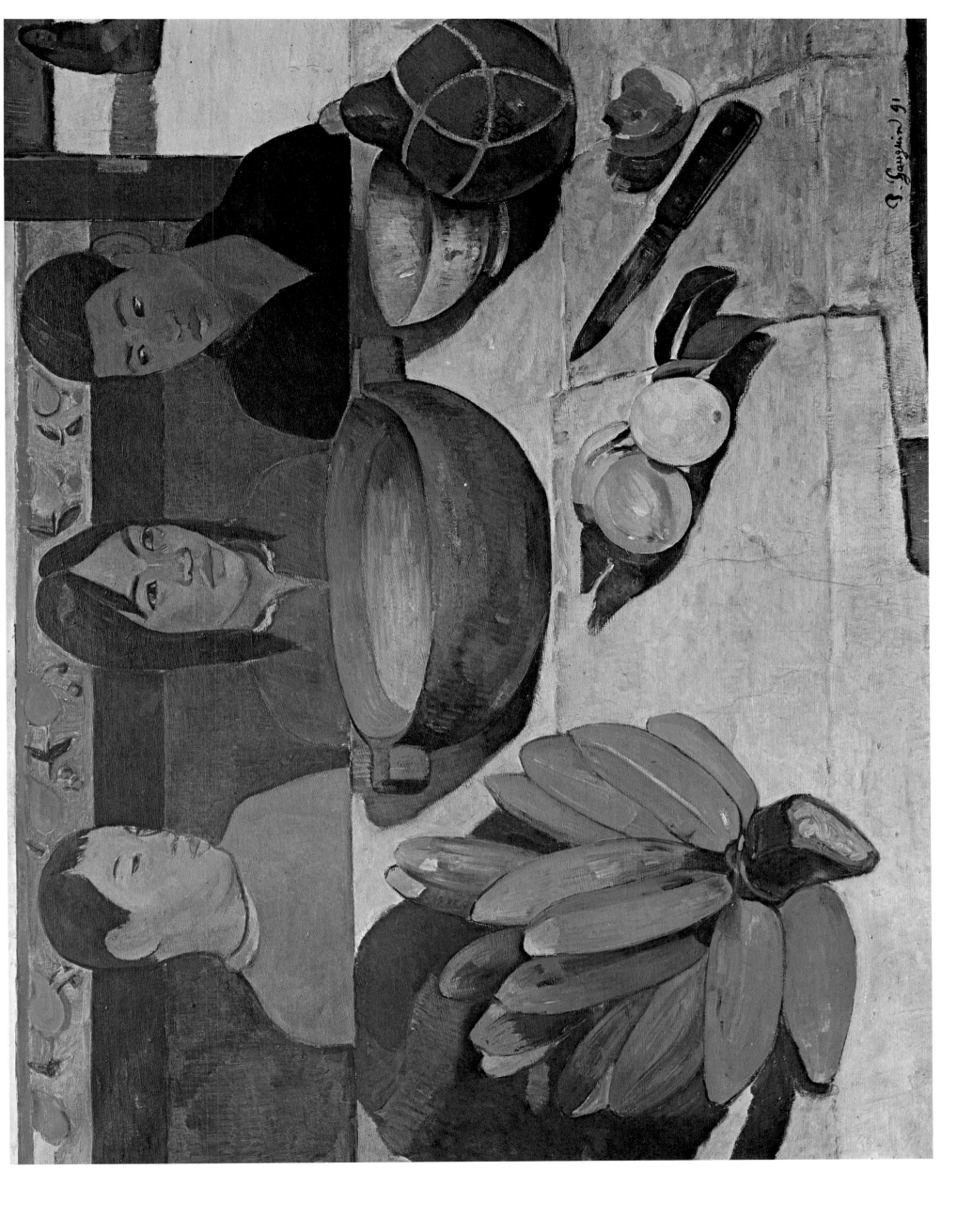

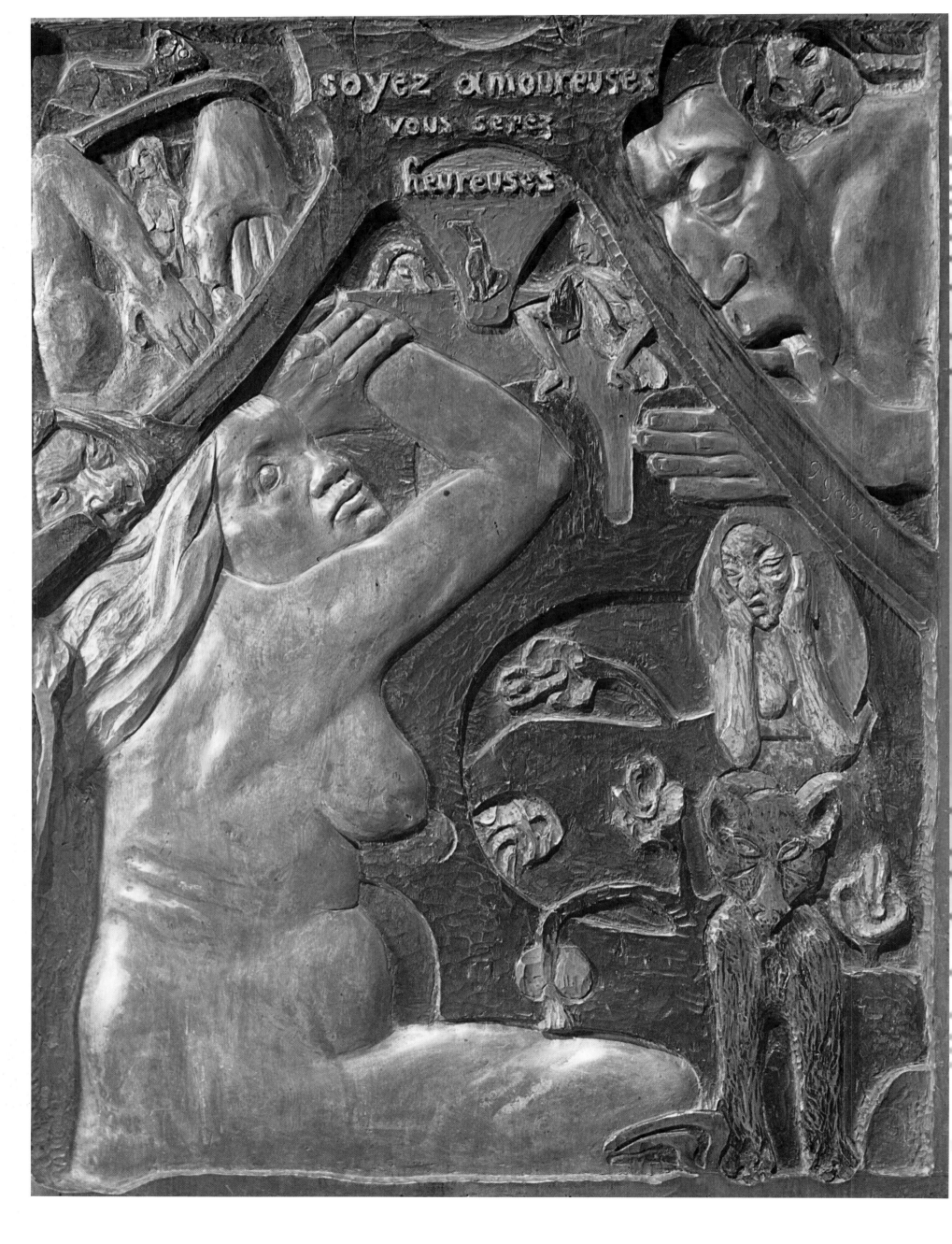

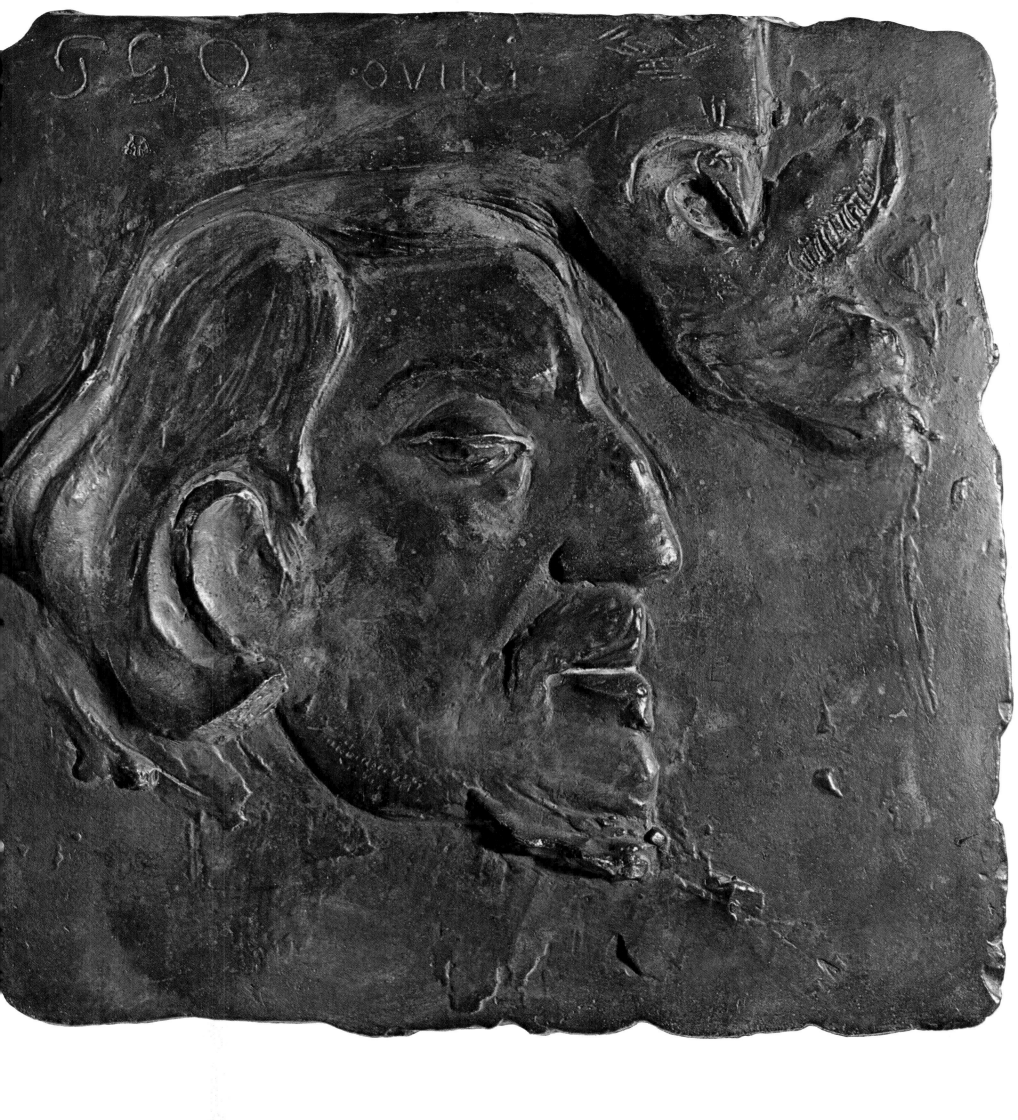

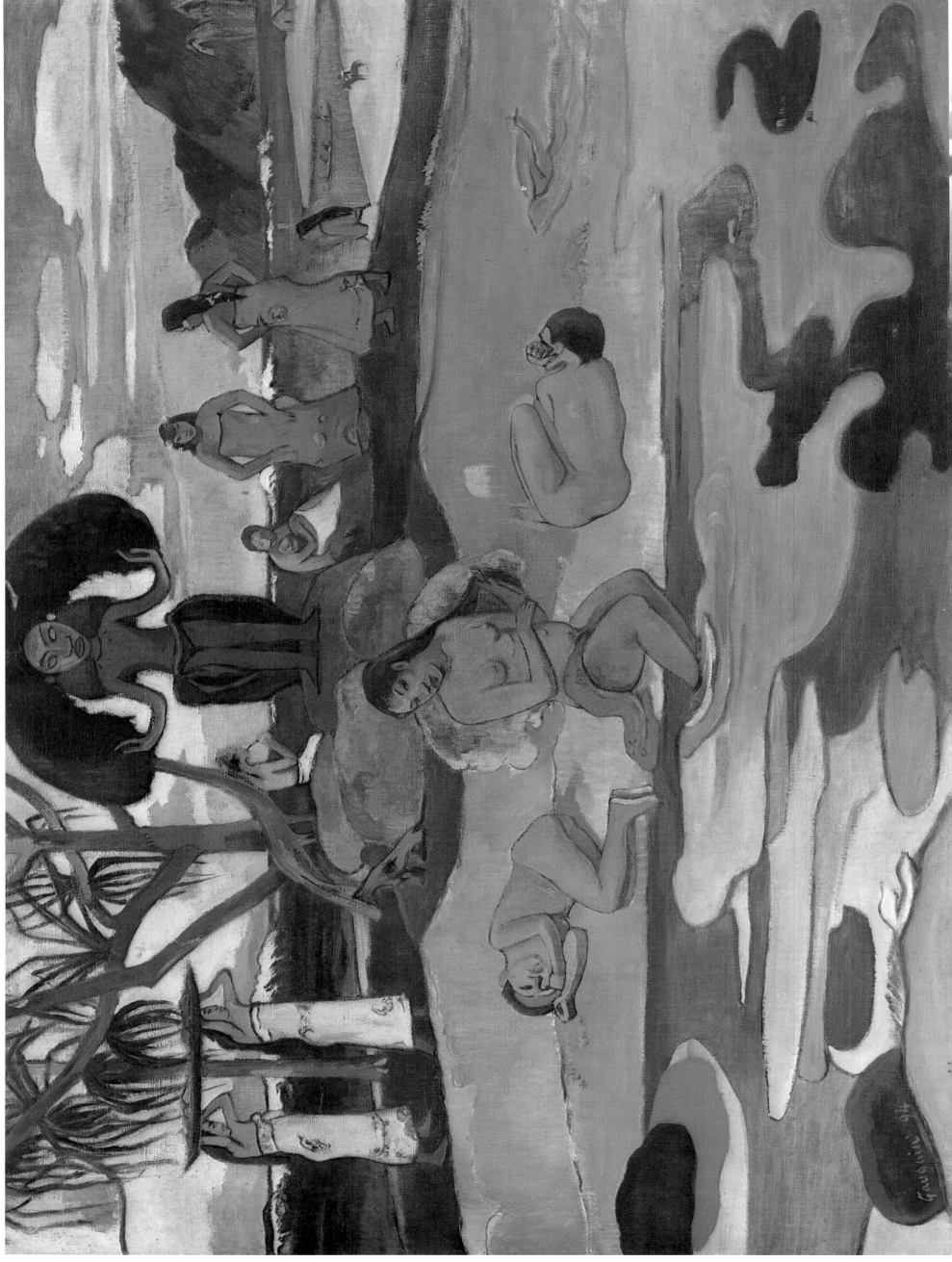

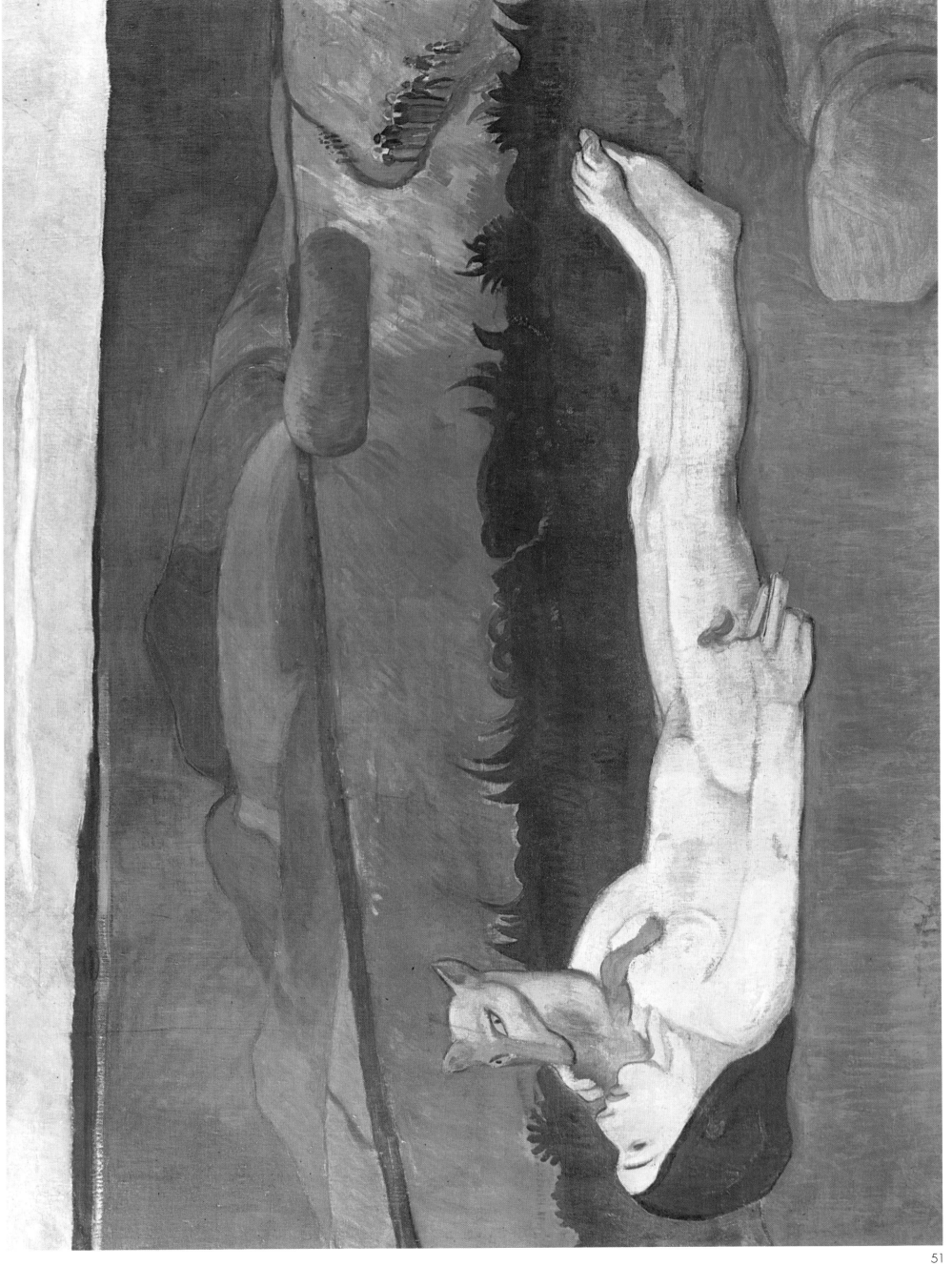

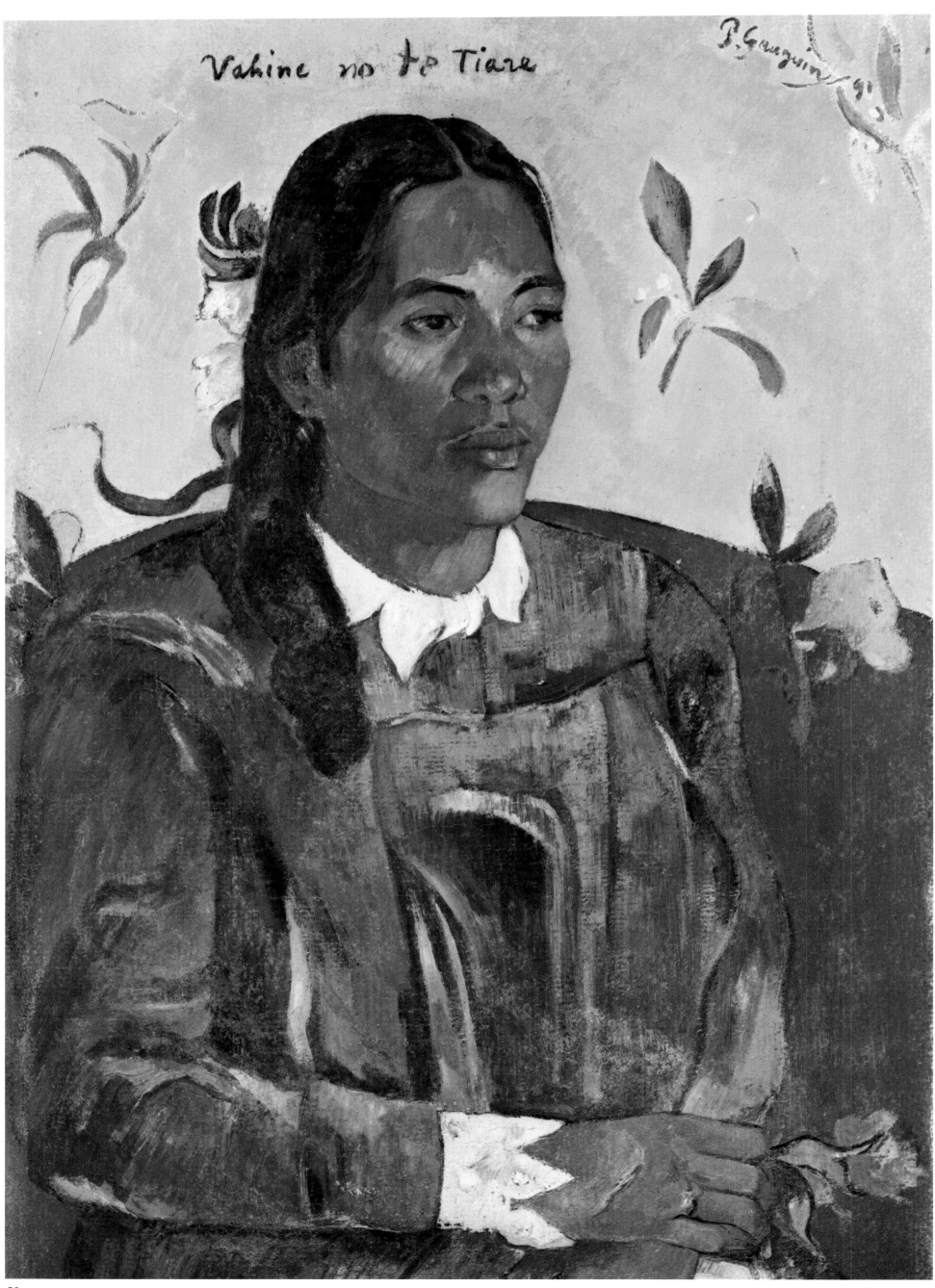

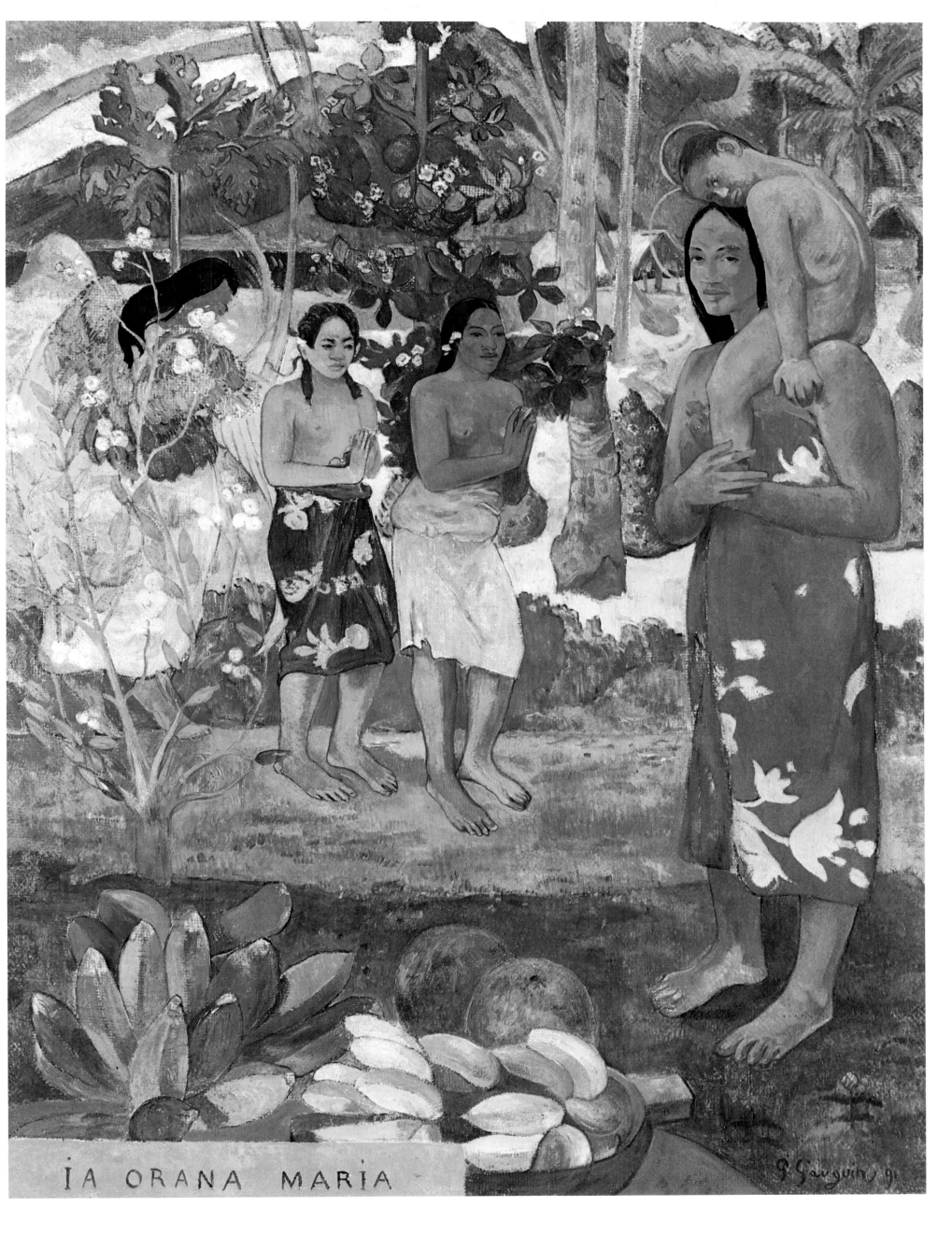

IA ORANA MARIA

P Gauguin 91

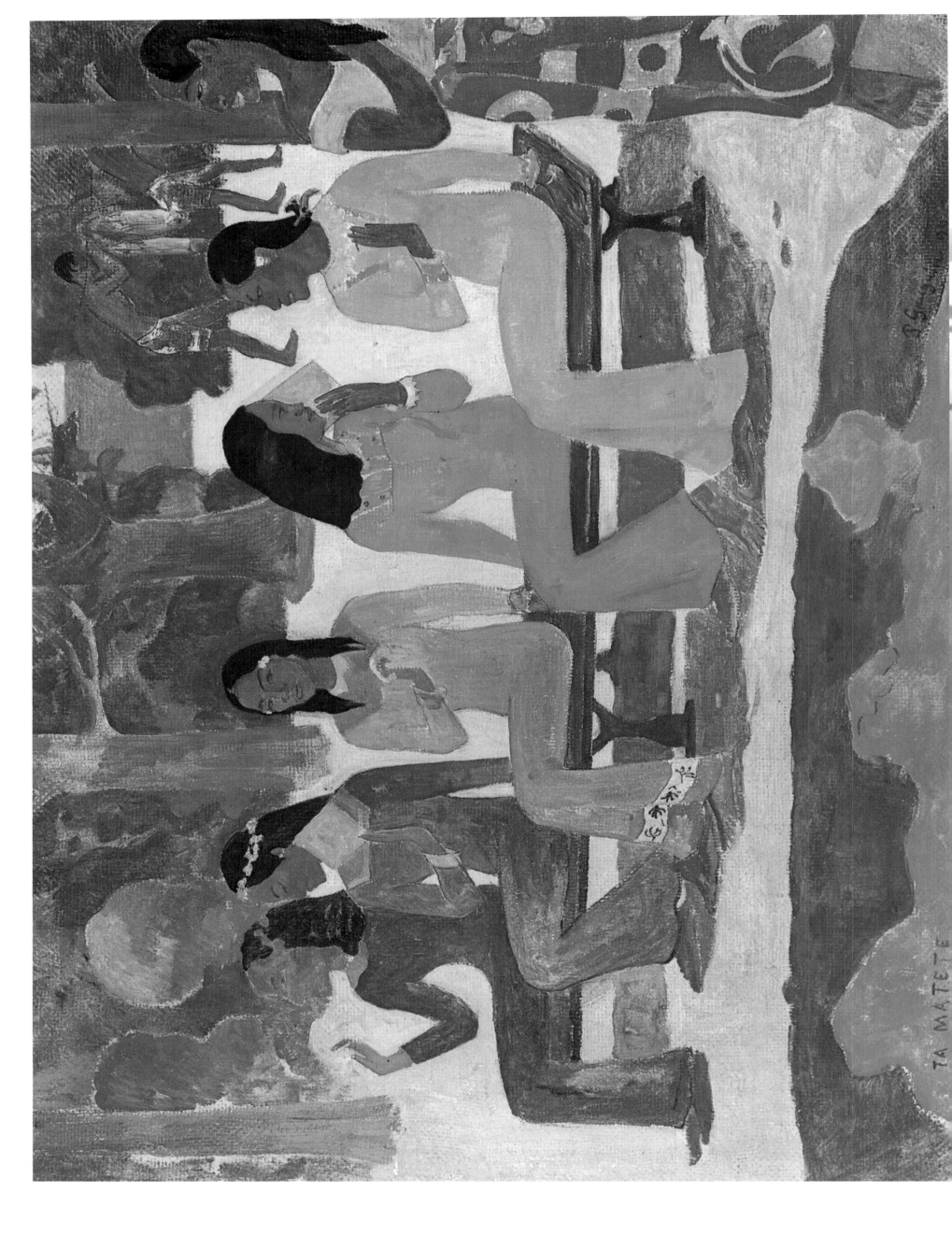

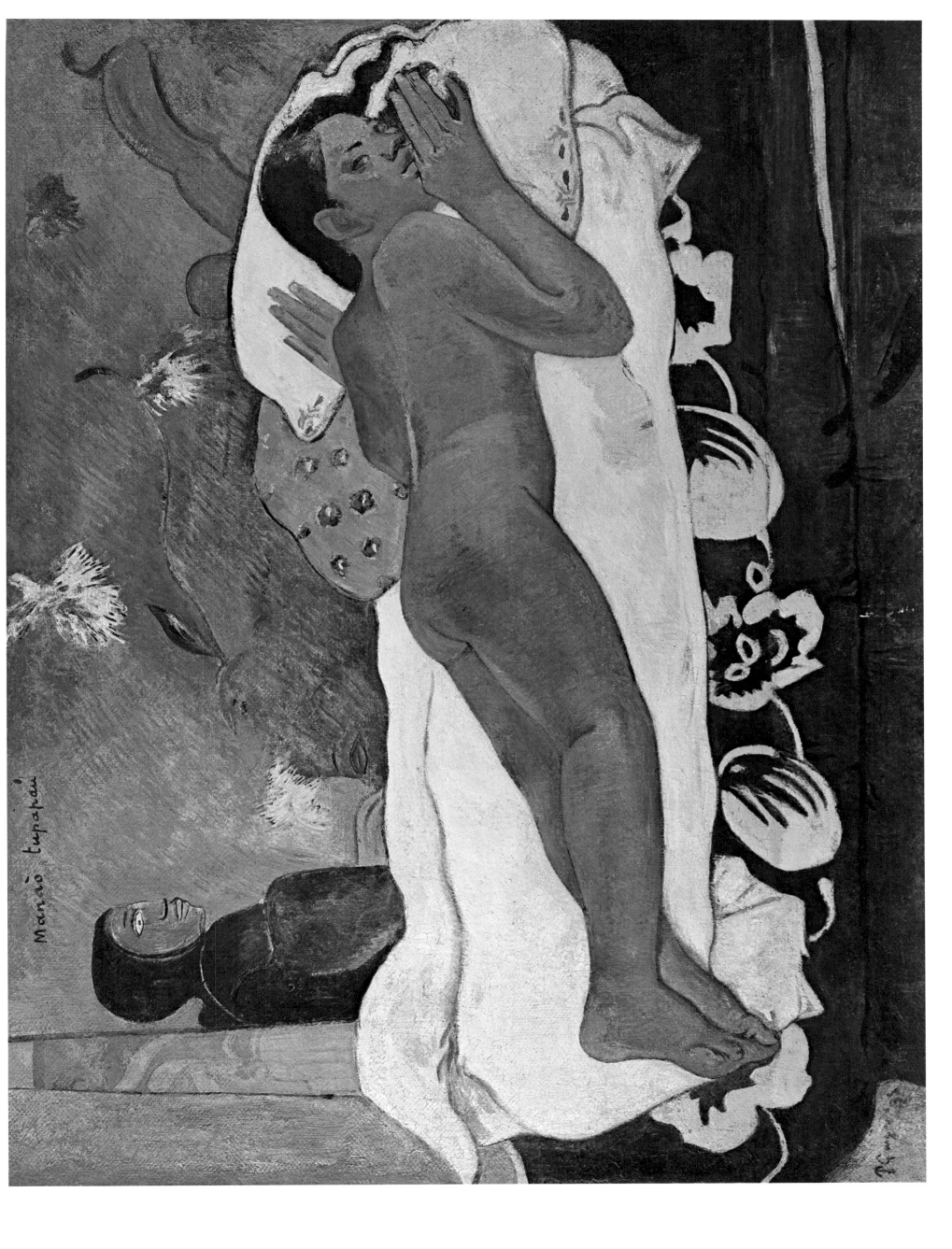

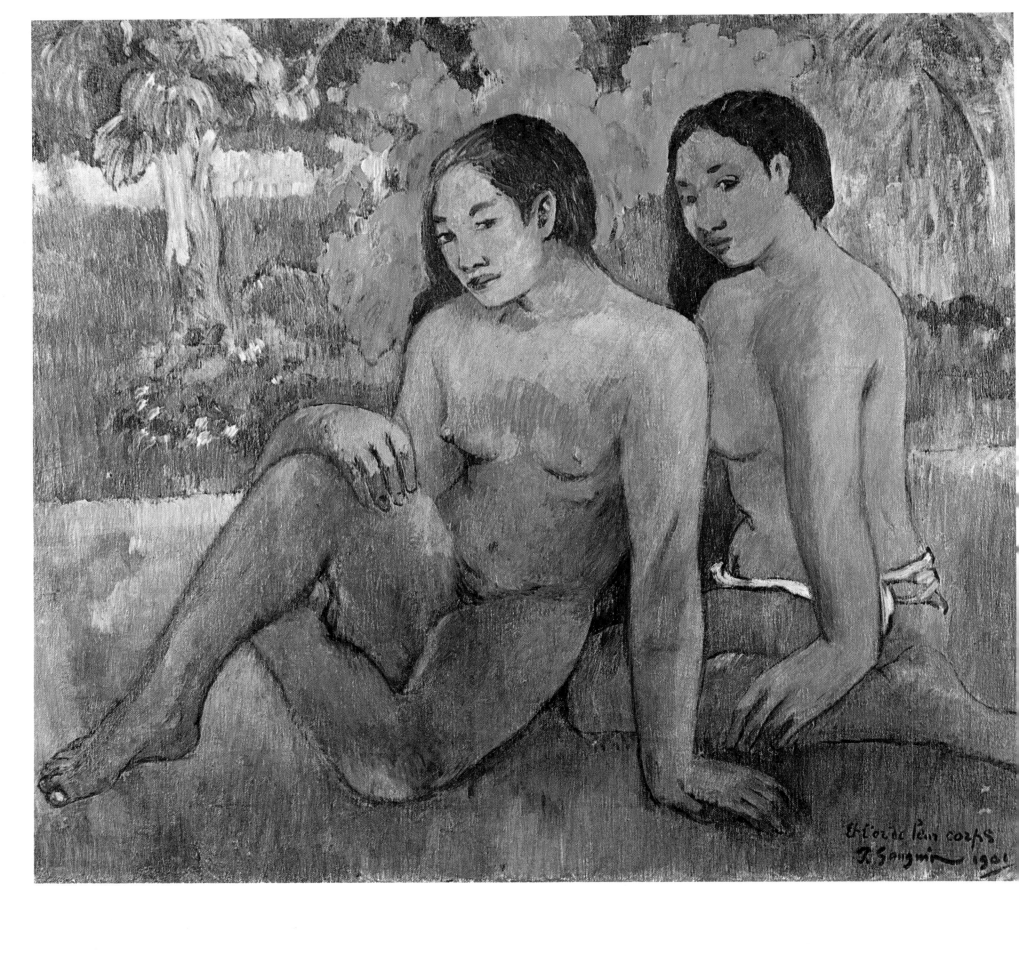

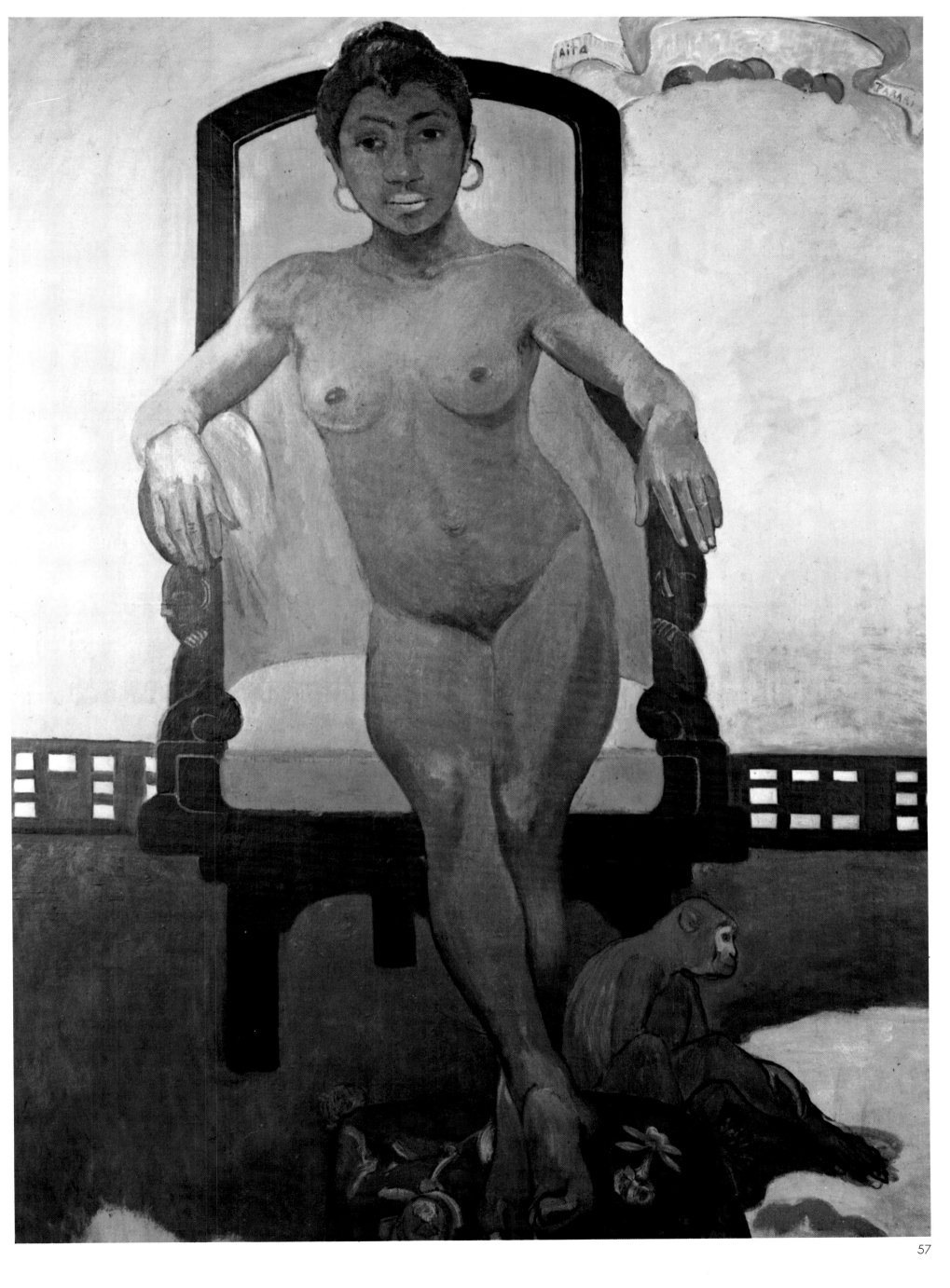

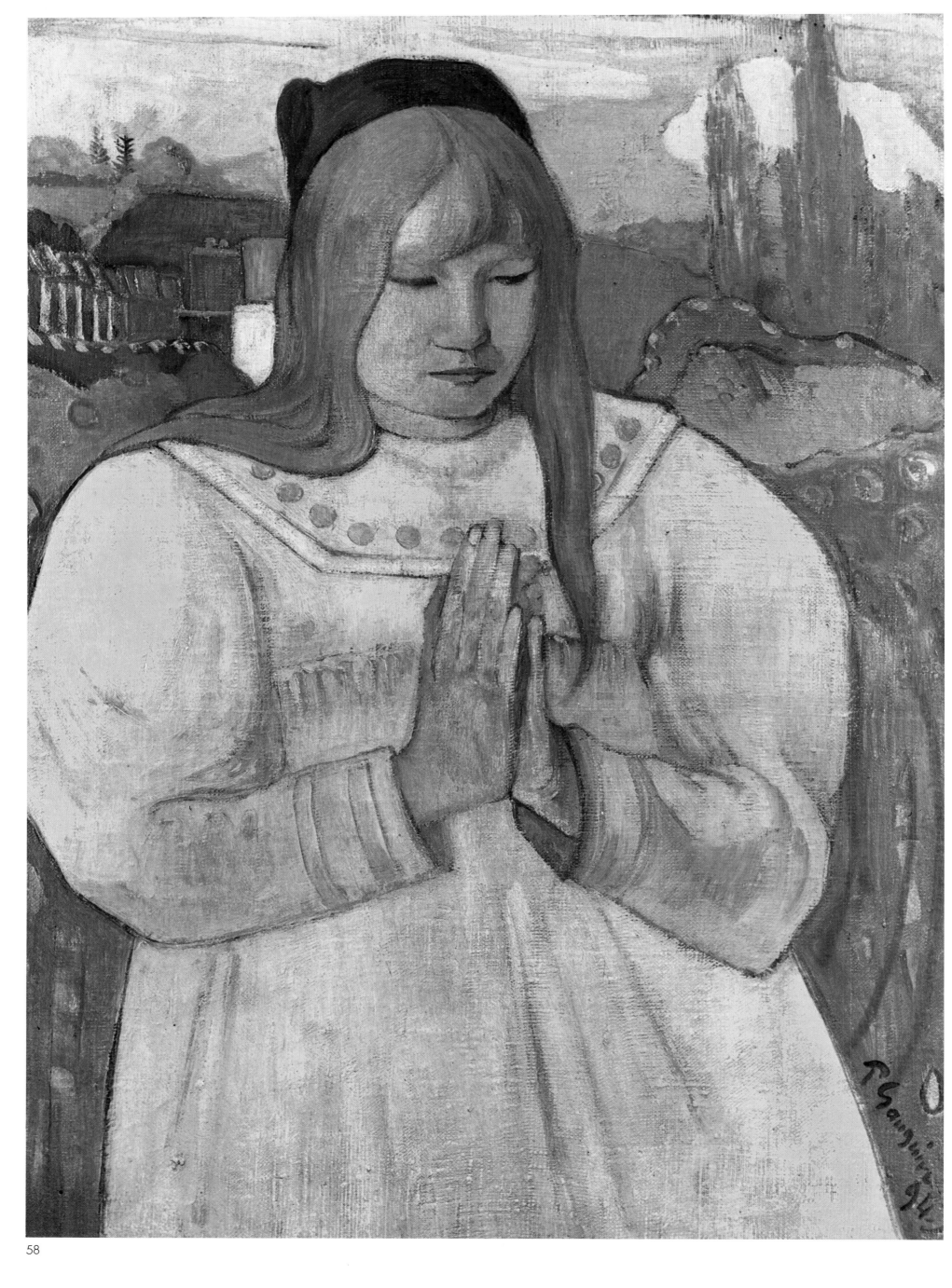

58

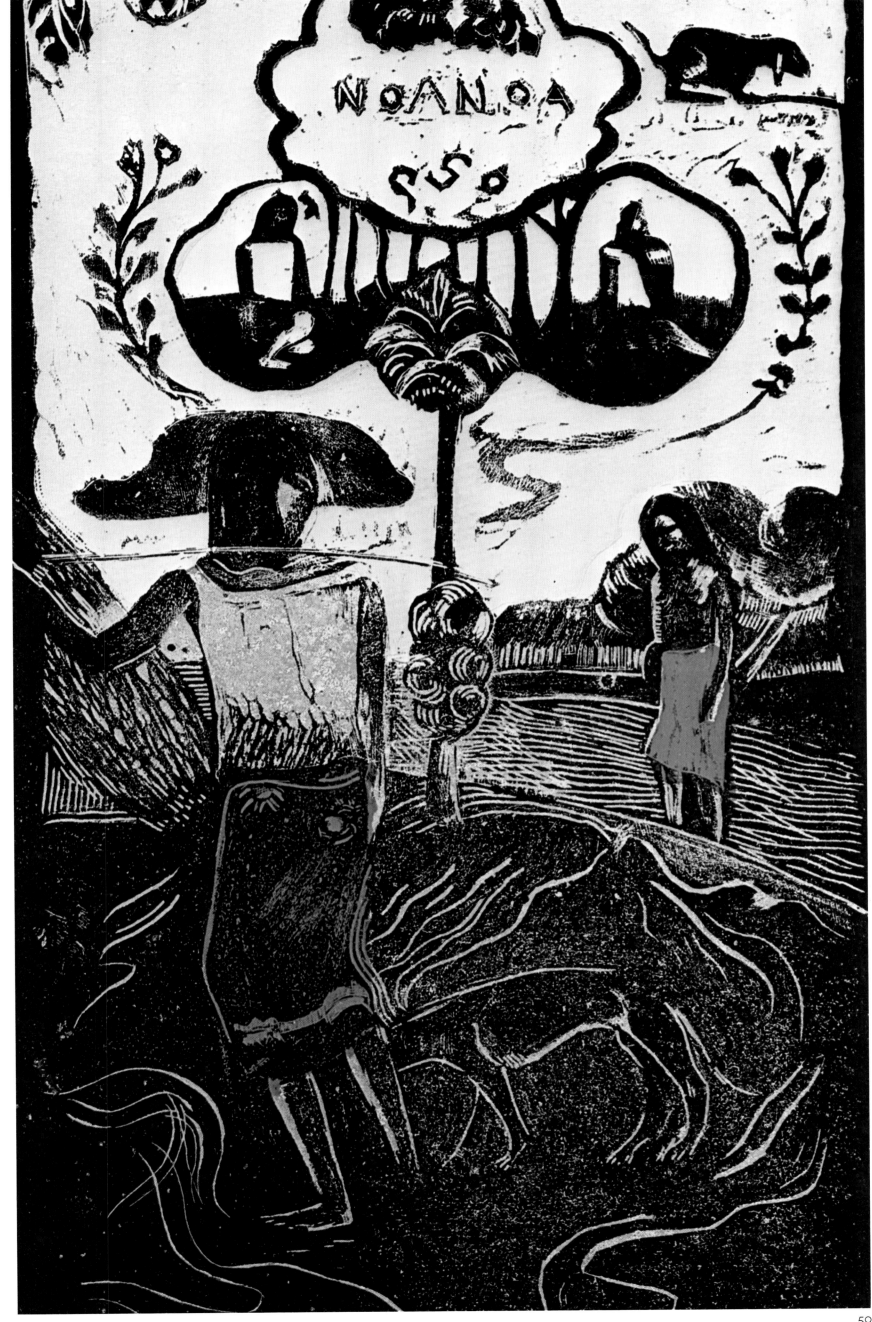

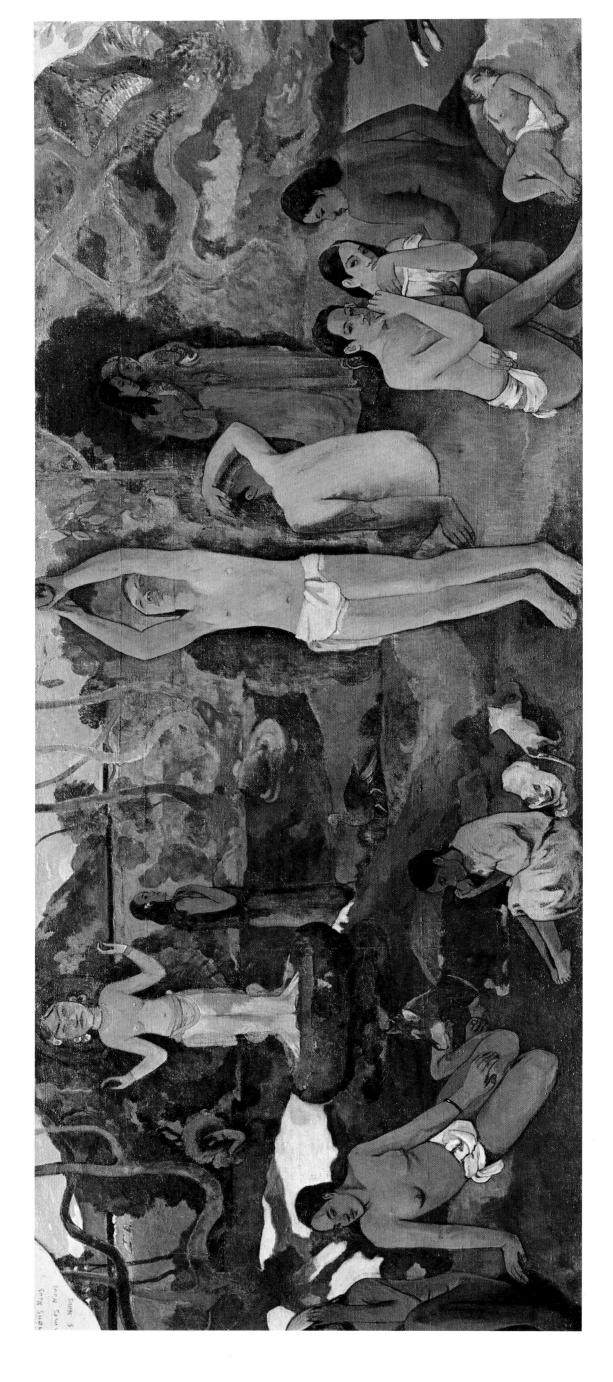

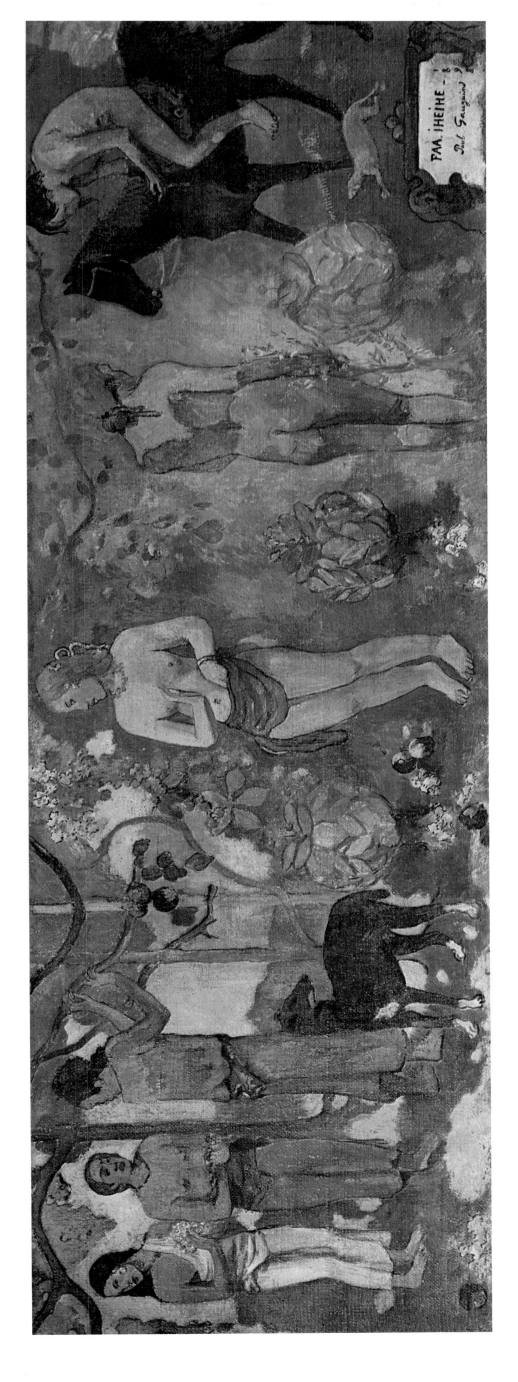

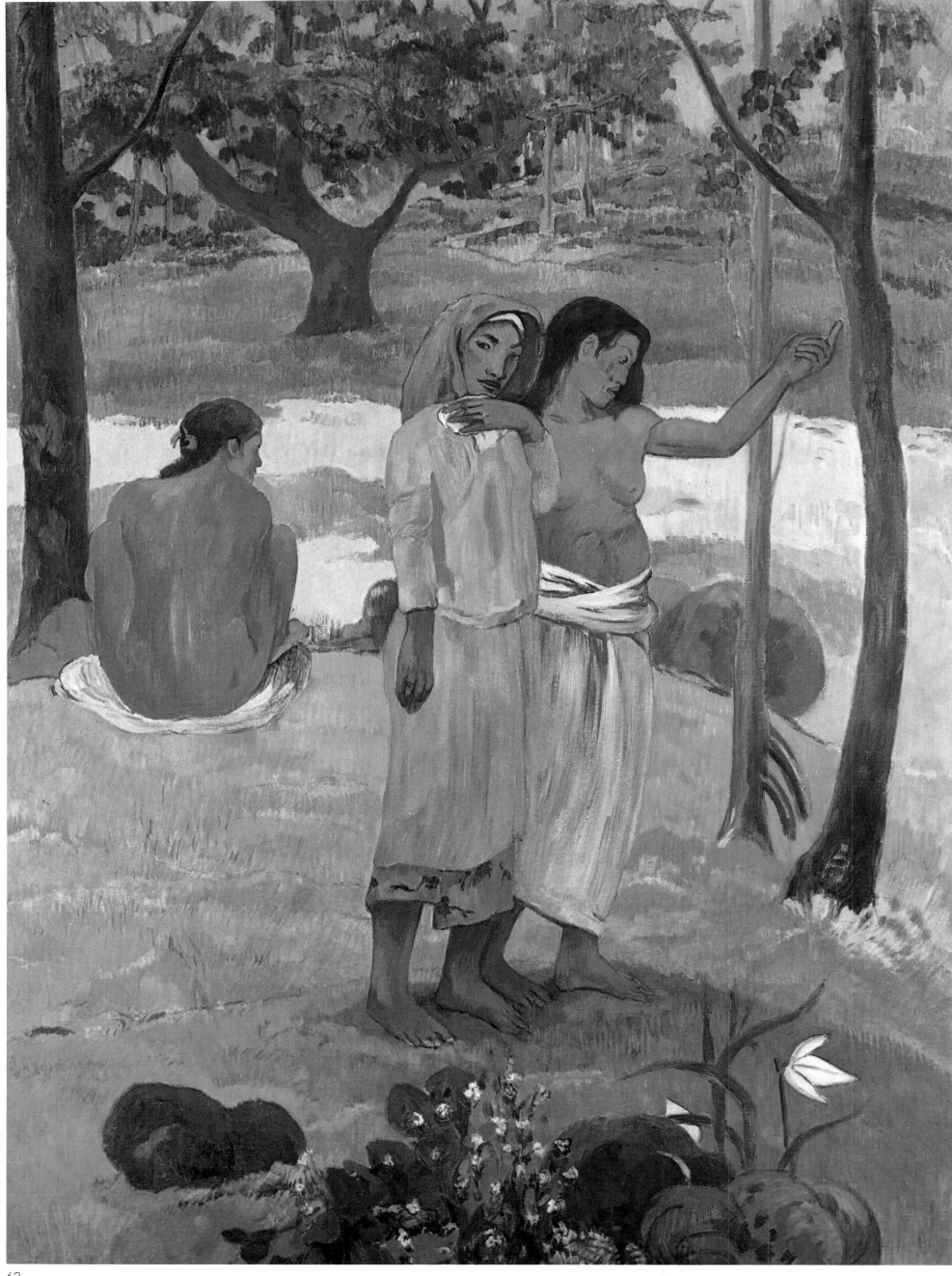

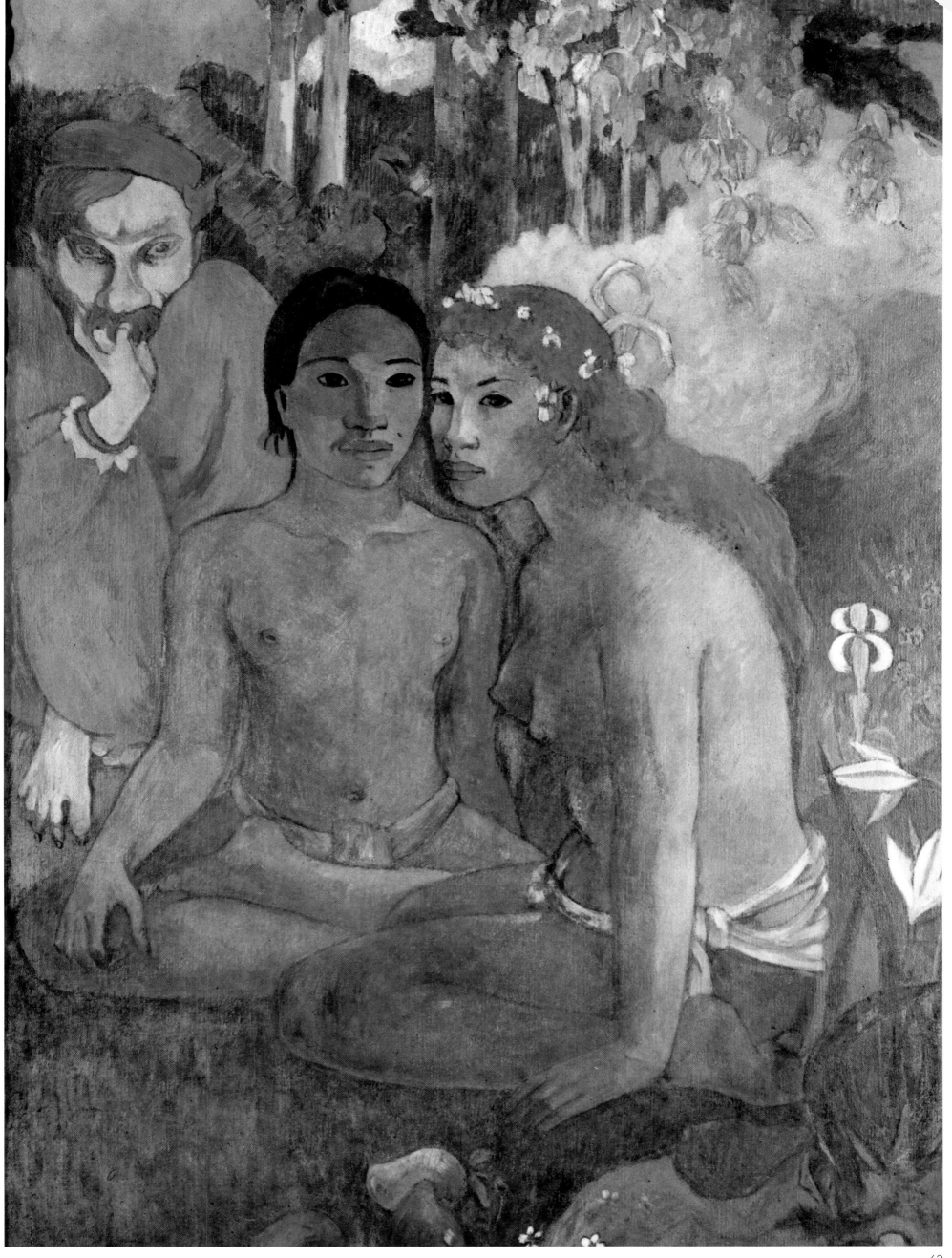

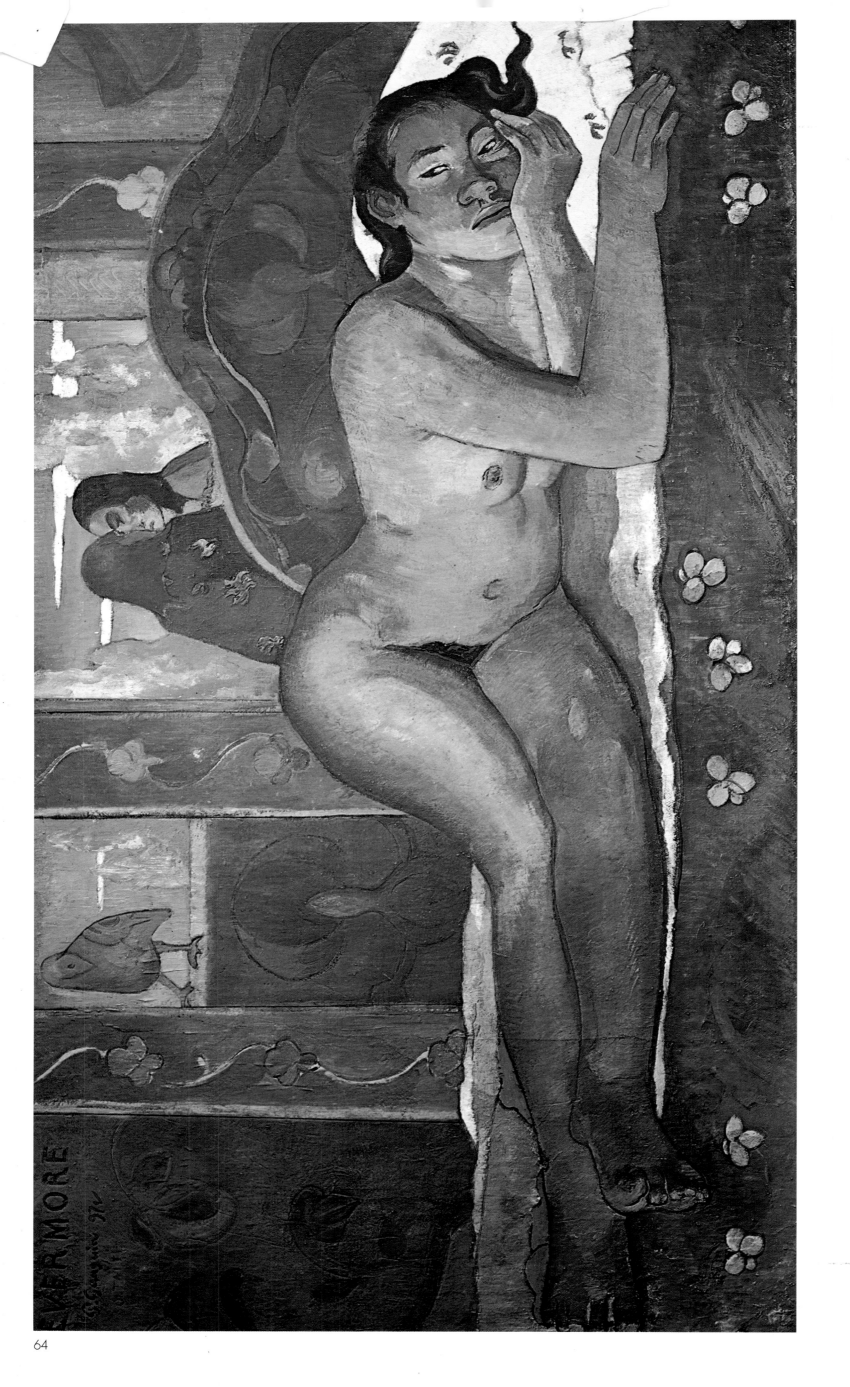